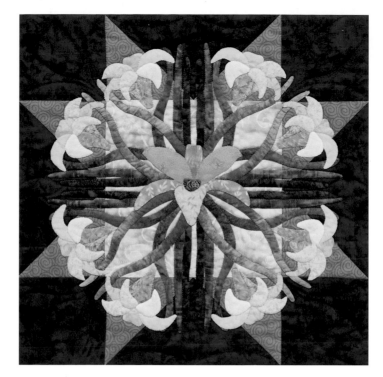

Another Season of Beautiful Blooms

Appliquéd Quilts and Cushions

SUSAN TAYLOR PROPST

Martingale®
& COMPANY

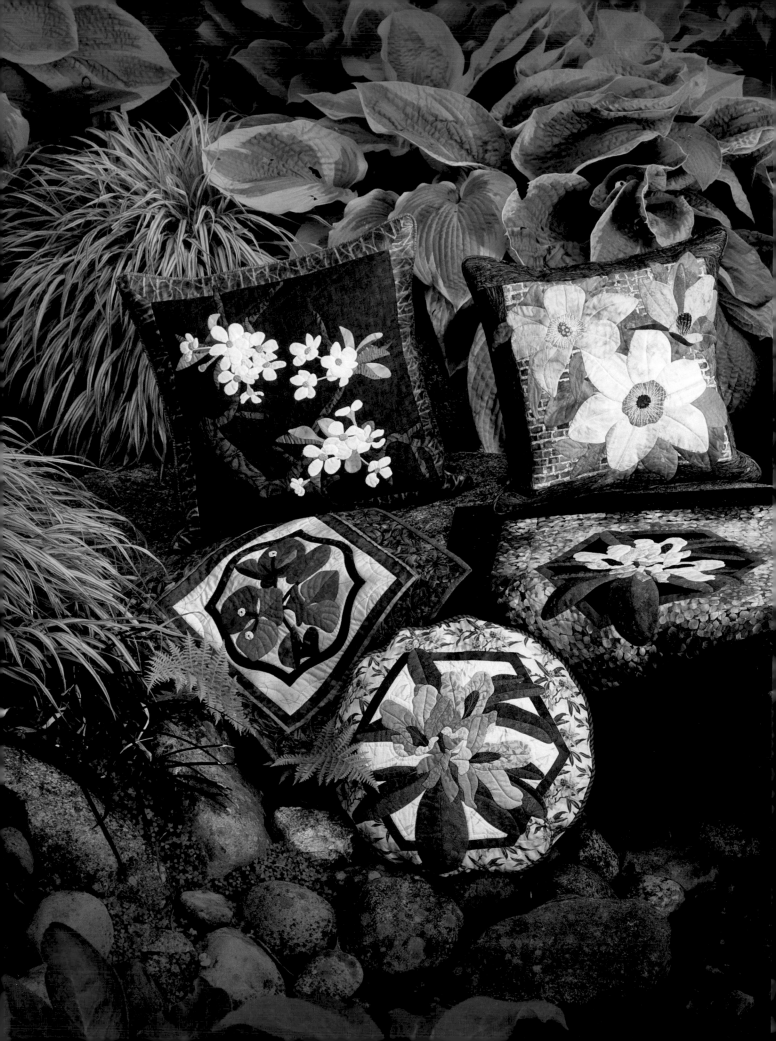

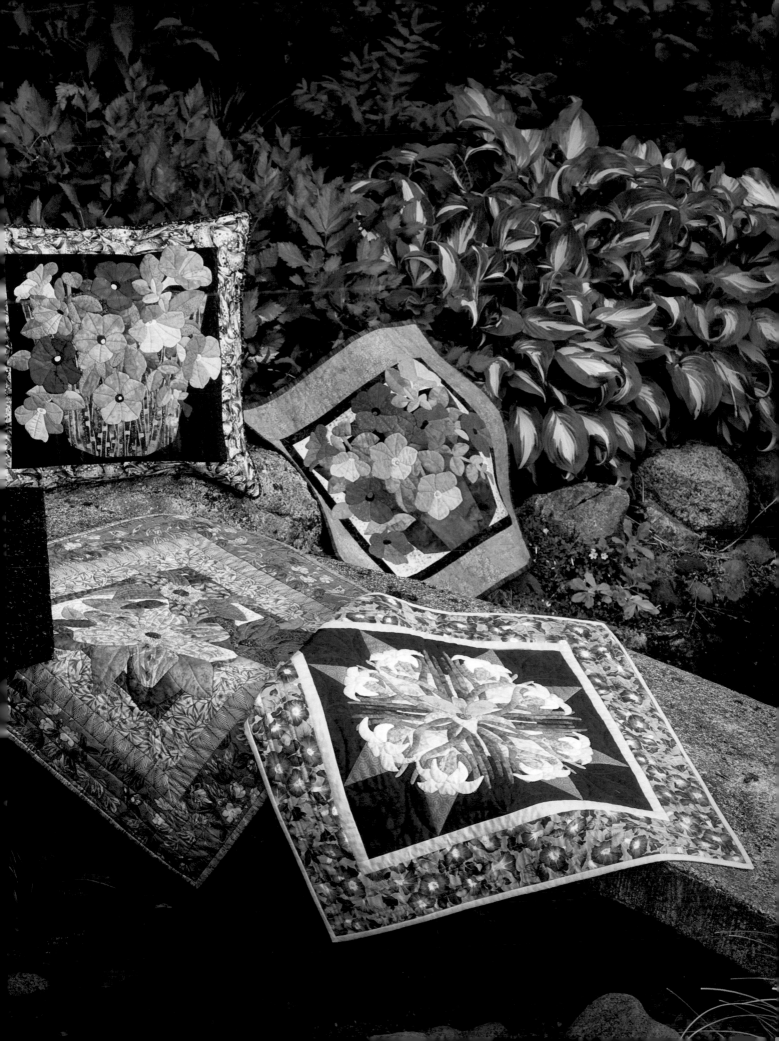

Montpelier Hill, Harrogate, England. Photo by Jonathan Propst.

Another Season of Beautiful Blooms: Appliquéd Quilts and Cushions
© 2010 by Susan Taylor Propst

That Patchwork Place® is an imprint of Martingale & Company®.

Martingale & Company
20205 144th Ave. NE
Woodinville, WA 98072-8478 USA
www.martingale-pub.com

Printed in China
15 14 13 12 11 10 8 7 6 5 4 3 2 1

**Library of Congress
Cataloging-in-Publication Data
is available upon request.**

ISBN: 978-1-56477-939-7

Mission Statement

*Dedicated to providing quality products
and service to inspire creativity.*

Credits

President & CEO ❖ Tom Wierzbicki

Editor in Chief ❖ Mary V. Green

Managing Editor ❖ Tina Cook

Developmental Editor ❖ Karen Costello Soltys

Technical Editor ❖ Laurie Baker

Copy Editor ❖ Melissa Bryan

Design Director ❖ Stan Green

Production Manager ❖ Regina Girard

Illustrator ❖ Laurel Strand

Cover & Text Designer ❖ Regina Girard

Photographer ❖ Brent Kane

Crescent Gardens, Harrogate, England. Photo by Jonathan Propst.

Acknowledgments

Profound thanks to the editors and staff at Martingale, who are so fabulous to work with and have helped every step of the way. Your work is truly exceptional!

Love and thanks to my husband, Chris, and my children, who encourage me, are often my best critics, and provide support in every way possible.

Thanks to the many people who have given me encouragement, inspiration, and feedback, but especially the Yorkshire Yank quilters and my students.

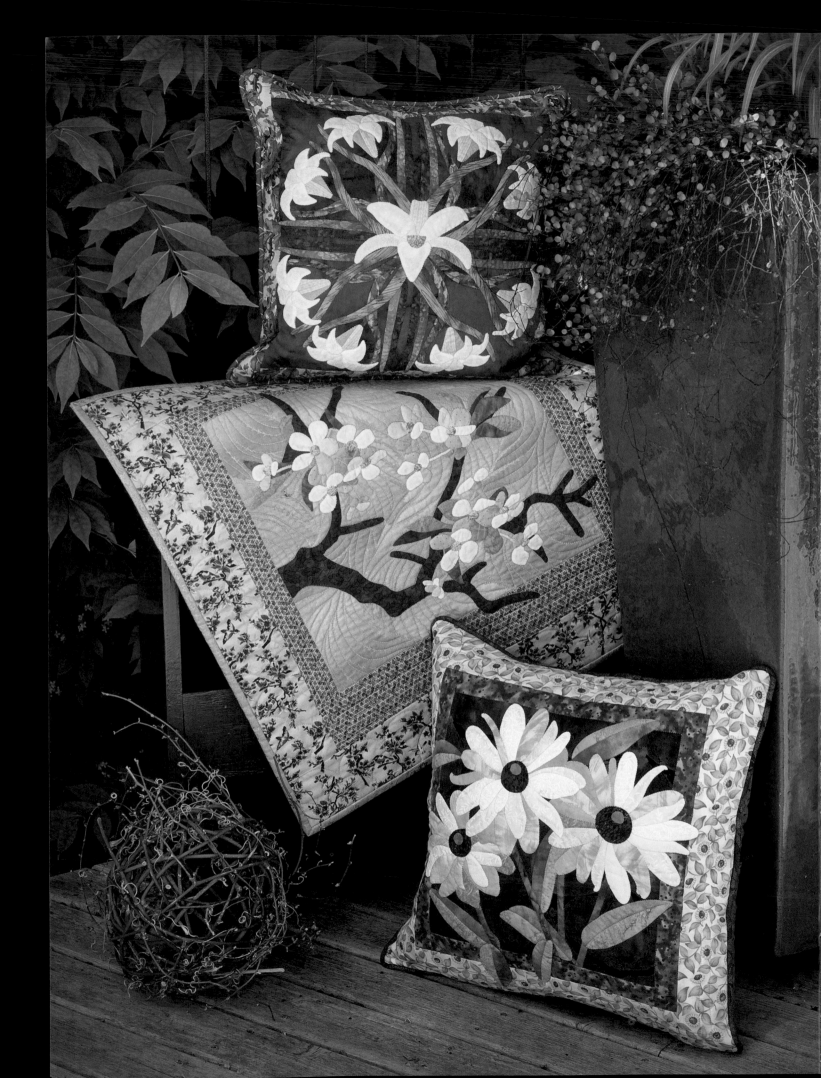

Contents

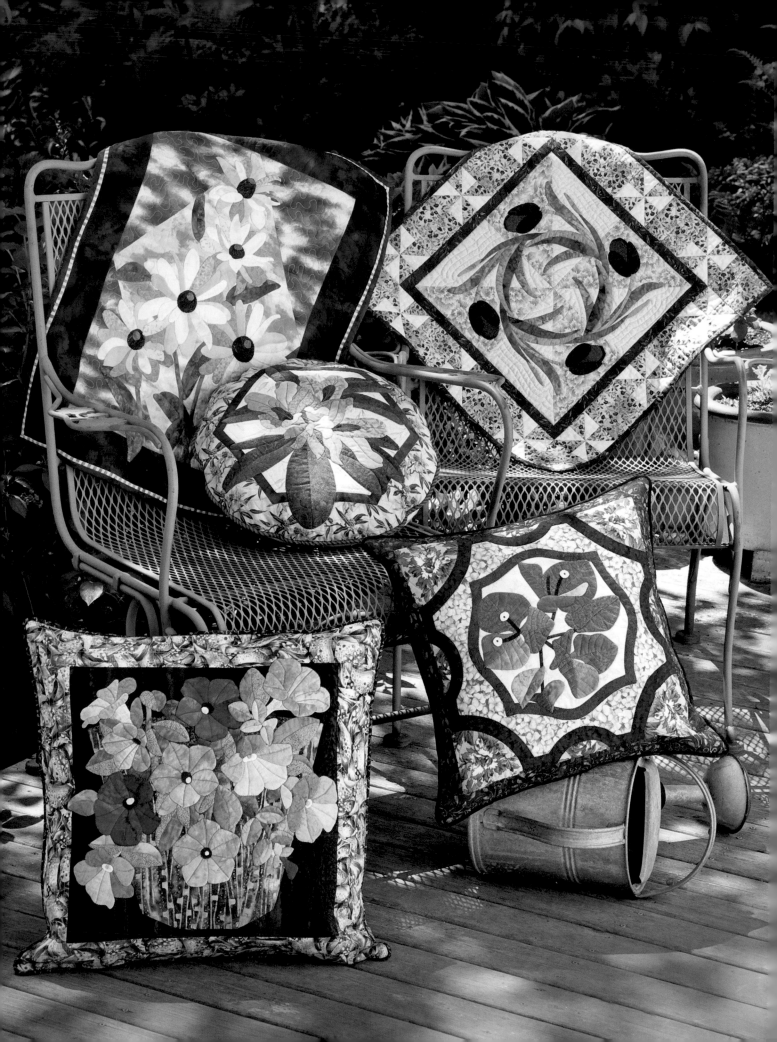

Introduction

I have always loved flowers. I know I got this at least in part from my mother, who lovingly planted and tended flower-beds in our garden. It was when I moved to England that I really started paying attention to the flowers around me. The abundance of flowers here has been such an inspiration. Every time I take a walk or visit a new village, I am impressed with the variety and beauty of the flowers so enthusiastically planted. Now I notice flowers more when I travel and often find flowers that I have never seen before outside of a greenhouse. When our family traveled to Portugal, we were so delighted to see large shrubs of poinsettias. We had never before seen a poinsettia that wasn't grown in a pot!

With nature providing so much inspiration, I have felt compelled to preserve impressions of these fabulous flowers in fabric. I am fortunate to have a husband who loves to take photographs, and I often use his photographs as a resource. You have the option to use my fabric selections and the color keys included with each pattern as a guide, or you can experiment with your own color combinations. The great thing about most flowers is that they come in a variety of colors, and you can even invent your own flowers by using unusual color combinations.

In this book, you will find designs for nine different flowers. Included are instructions to make each design as both a cushion and a wall hanging. Some of the patterns have pieced backgrounds. Feel free to either follow the patterns as presented or choose the background you want with the flowers you want to appliqué.

Many of these designs look very complicated, but because I make the samples myself, I try to keep the stitching as simple as possible, minimizing those tricky inside corners. That means that these designs are great for hand appliqué, but can also be done with fusible appliqué. One of the best things about appliqué, and appliqué flowers in particular, is that the result does not have to look exactly like the pattern. Flowers are quite varied, so relax and enjoy the appliqué. If yours looks different from mine, it's just your own unique version of it. If you are new to appliqué, I've included instructions in "The Appliqué Process," beginning on page 17. Because many pieces overlap, I strongly recommend using an overlay method, discussed in that section as well. I've also introduced some optional dimensional embellishments on several of the designs. The most important thing is that you create your own cushions and wall hangings that reflect your personal fabric tastes. In other words, have fun and let your creativity flow as you create your own beautiful blooms in fabric!

Bluebells at Swinsty Reservoir, Yorkshire, England. Photo by author.

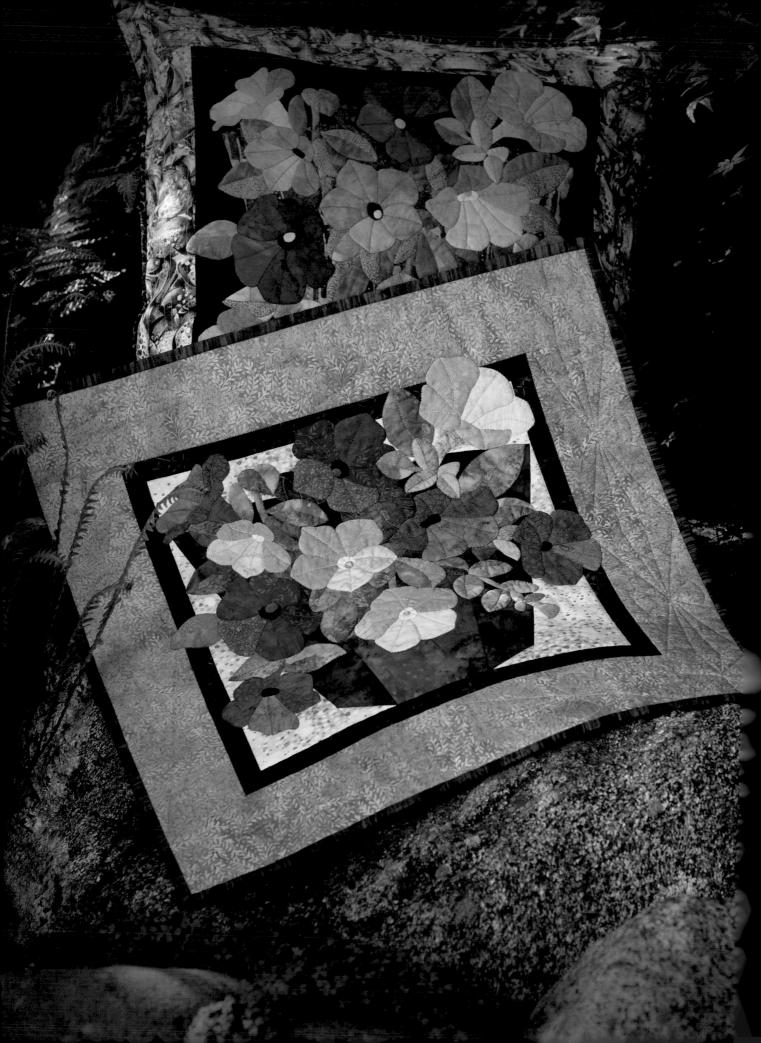

Complementary Contrast

Each color has a hue that is its opposite on the color wheel, such as green and red, purple and yellow, and blue and orange. When you use opposite colors, they enhance each other and they both look more brilliant. For example, red will look the most red when it's next to green.

Colors opposite each other are complementary.

While the effect of complementary colors is most dramatic with pure hues, you can also use a less-saturated color to get a nice effect. Even if the colors are not precisely opposite but nearly opposite, they will enhance each other. The "Lily" wall hanging below uses complementary contrast; the center flower is made of a yellowish orange fabric that is opposite the purplish blue in the background. Notice that the wall hanging also has contrast of value and contrast of saturation, demonstrating that you can use all the types of contrast together.

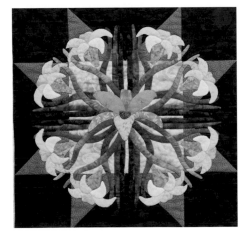

Print

When deciding what colors you want to use in your appliqué, you can choose color combinations that you like and try to find fabrics to match, or you can choose a focal fabric that you love and draw your colors from that fabric.

Borders

It is important for the borders to provide a frame for the quilt, but not to dominate the quilt. The colors in the borders shouldn't be too strong for the appliqué pieces.

Starting with a focal fabric is often the easiest way to select your borders. A focal fabric is a fabric that contains some or all of the colors that you want to incorporate into your quilt. Once you have your focal fabric, you can then find fabrics that coordinate with it to use for your background and appliqué. Sometimes I start with the appliqué first and choose the border fabric second, but this can be tricky if you don't have a large stash because you may not be able to find a suitable border fabric. Sometimes you might be fortunate enough to find a fabric that contains the flower you are appliquéing. For example, the "Black-Eyed Susan" cushion below has a border fabric that contains black-eyed Susans, and I used the colors in this fabric to direct my color choices. However, you can certainly use almost any fabric for the border. A fabric containing a different type of flower can be used if you like the colors.

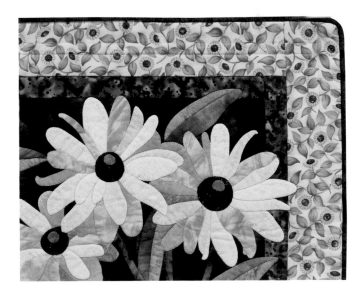

Sometimes an abstract fabric, such as the fabric I used in the "Petunia" cushion (page 35), makes the quilt feel updated and fresh.

Background

The background fabric should support the appliqué but not overwhelm it. There are two things to consider when selecting the background. The first is that it should contrast with the appliqué. Usually this can be best achieved when the background is a different value than the appliqué. For example, if the flowers are of medium value, a light or dark value works well for the background. If the background is pieced or the appliqué extends into the border, then you can be strategic about where to place certain fabrics so they will be visible. The "Petunia" wall hanging, for instance, has a pale background, so pale flowers wouldn't have shown up well. However, the flower in the upper-right corner is mostly positioned over the medium-value border, so a pale pink fabric works fine.

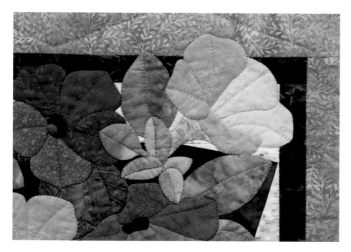

Carefully chosen fabric and placement allow this pale flower to stand out.

The second consideration is the texture of the background. While solid fabrics are a safe choice, a textured fabric adds dimension to the piece. You just have to be careful to make sure that the fabric is not so busy that the appliqué gets lost. Usually fabrics with too much color or value contrast will not make good background fabrics.

The fabrics on the top are more suitable background choices than the busy fabrics on the bottom.

Appliqué Pieces

My favorite fabrics for appliqués are hand-dyed fabrics—these are the foundation of my appliqué stash. They have a higher thread count and finer feel than many printed fabrics, which makes the appliqué process easier, and the subtle color variations provide a bit of texture that solid colors don't offer. There is also a huge range of colors available, so you should have no problem finding a fabric that will represent most flowers and leaves.

A selection of good appliqué fabrics

It is probably easiest to use tone-on-tone fabrics, but sometimes it is fun to use prints, particularly when the print suggests the texture of the flower or leaf to be appliquéd. If you are using fabrics that have a strong print, be careful that they stand out from other pieces around them.

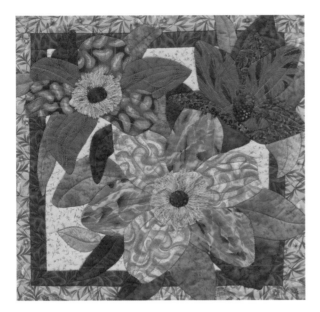

In the "Clematis" wall hanging (page 97), I played around with some stronger prints for the flower fabrics, and it gives the piece texture and a playful feel.

Effect of Lighting

The use of different types of lighting throughout your home makes the selection of fabrics a bit challenging. In particular, the recent trend toward the use of compact fluorescent lamps (CFLs) adds to the challenge. Before, we mostly had to worry about natural light and incandescent bulbs, but fluorescent bulbs change the appearance of colors, and some colors can change drastically. In addition, some CFLs are closer to daylight than others. I have an inexpensive CFL in my sewing room as well as a daylight lamp. The reasoning behind having both lamps is that most of the bulbs in the rest of the house are now CFLs. When I make fabric choices, I want the combinations to look good in all rooms, daylight or nighttime. When I select fabric, I try to work during the day and pick what looks good in natural light, and then I close the curtains and turn on the fluorescent light to make sure everything still looks good together. It's amazing how completely different some fabric colors will look, and often I end up changing a few of my fabric choices to make sure that the quilt will look good in any light.

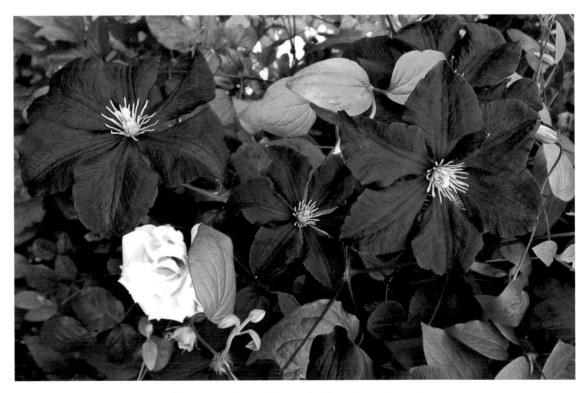

Clematis blooms. Photo by Jonathan Propst.

The Appliqué Process

Flower shop, King's Road, Harrogate, England. Photo by Jonathan Propst.

The instructions given here describe my preferred techniques for hand appliqué, but the patterns for the projects are adaptable to other methods. If you plan to use an appliqué method other than the hand techniques given here, note that the patterns do not include seam allowances and the shapes have not been reversed.

Creating a Placement Guide

The first step is to create a guide for placing the appliqués on the background fabric. Rather than tracing the design directly onto the fabric, I like to trace the design onto a plastic or vinyl overlay. You can purchase sheets of clear plastic or lightweight vinyl yardage for this purpose, or you can recycle plastic. The plastic needs to be fairly firm and large enough to contain the entire appliqué design. Dry-cleaner bags are a bit too thin, but I have successfully used the plastic wrapping from new shirts. For smaller projects, you can cut open a plastic page protector. Use a permanent marker to trace the entire design onto the plastic, including the numbers on each appliqué shape and the border lines, where given.

Along with using the overlay to position your appliqué pieces, you can also use it to audition your fabric choices before you begin to stitch. Just cut out the appliqué pieces as

described below, place the overlay over the background fabric, and slide the pieces into place. Although the project will look a bit different once the pieces are stitched, you will be able to see if the chosen colors work well together. You can even pin the appliqué pieces to the plastic and then audition a variety of potential background fabrics.

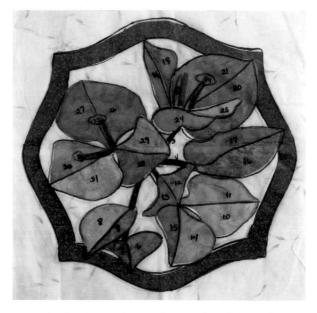

A plastic overlay with pieces underneath

Preparing the Appliqués

You will need to make a freezer-paper template for each appliqué piece. To do this, lay a piece of freezer paper, *shiny side up*, over the pattern. Using a mechanical pencil, trace around each numbered shape, leaving a little bit of space around each one. Cut out each template on the marked line. Do not add seam allowances. Write the number of each piece on the dull side of the template. Place each shape, *shiny side down*, on the wrong side of the chosen fabric. Using a hot, dry iron, press the freezer-paper templates onto the fabrics. Cut around each piece, leaving a seam allowance of approximately ³⁄₁₆".

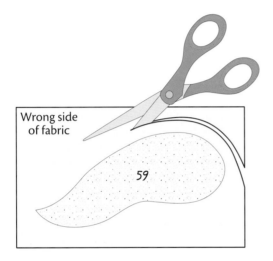

If the freezer paper does not adhere well to the fabric, baste around the edges of the freezer paper by hand or machine after ironing the freezer paper to the fabric. Once the piece is appliquéd, the basting is easily removed.

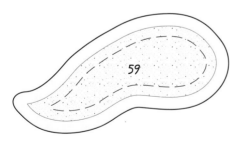

Positioning and Stitching the Appliqués

1. Prepare the background piece as instructed for the individual project. For many of the designs, you will need to add one or more of the borders to the background fabric first because the appliqués extend onto them.

2. Position the overlay over the background piece, right side up. For projects on which borders have been added, align the border placement lines marked on the overlay with the border seam lines. For all other projects, follow the project instructions for aligning the overlay on the background.

3. Slide appliqué piece 1 under the overlay so that it is aligned beneath the corresponding shape of the design. Remove the overlay. Baste or pin the appliqué in place. If you baste, make sure the stitching is not within the ¼" seam allowance, which will be turned under. If pinning, use ¾" appliqué pins.

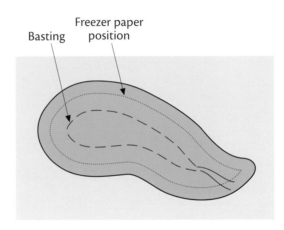

4. With the thread still on the spool, thread a size 10 or 11 straw or milliner's needle with a 50- or 60-weight cotton thread in a color that matches the appliqué. If you can't find an exact color match, choose one that is slightly darker, or use a neutral color (gray or beige) that matches the value of the appliqué fabric. Cut the thread, preferably no longer than the distance from your elbow to your fingertips. Thread longer than this tends to tangle and wear thin. Knot the end of the thread.

5. If possible, begin stitching along the straightest edge of the appliqué. If you are right-handed, you will probably find it easiest to stitch in a counterclockwise direction, and if you are left-handed, stitch in a clockwise direction. Using the needle, turn under the first ½" or so of seam allowance, using the freezer paper as a guide. Don't try to turn under too much at one time, just a little more than you are going to stitch. It is also important to avoid stabbing at the seam allowance with the tip of the needle, which can cause the fabric to fray. Bring the needle up from the background fabric just under the turned-under edge of the appliqué piece. Insert the

General Instructions

This section will guide you through the steps for adding borders with either butted corners or mitered corners, and it will also discuss the quilting process. Finishing instructions for cushions begin on page 29; finishing instructions for wall hangings begin on page 32.

Adding Borders

Regardless of whether you are making a cushion or a quilt, you will apply the borders in the same manner. The width and length of all border strips are specified in the project cutting instructions, but I strongly recommend that you measure your quilt top as described in this section before cutting the borders. My measurements are based on cutting pieces precisely and taking an exact ¼" seam allowance, but try as we might to achieve perfection, sometimes variances do occur.

Butted Corners

If your border fabric does not have an obvious direction, use borders with butted corners, which are easier to cut and stitch.

1. Measure the width of the cushion or wall-hanging top near the top edge, through the horizontal center, and near the bottom edge. If these three measurements are within ¼" of each other, make a note of the center measurement and continue with step 2. If not, you may need to rework the piece a bit to make it more square.

```
Top measurement

Center measurement

Bottom measurement
```

Walled garden at Castle Fraser, Scotland. Photo by author.

2. From the border fabric, cut two strips the length of the center measurement. I often just square up one end of my border strips, lay the strips across the center of the project with the squared-up ends aligned with the project left edge, and cut the opposite ends even with the right edge of the project.

3. Stitch one strip to the top edge of the project top and the other to the bottom, easing to fit as necessary. Press the seam allowances toward the border strips.

4. Repeat step 1 to measure the length of the project top near the left and right edges and through the vertical center, including the top and bottom borders. Square up the piece if necessary. Cut two border strips the length of the center measurement. Or, lay two border strips along the lengthwise center of the project top and trim them as described in step 2. Sew the strips to the sides of the piece. Press the seam allowances toward the border strips.

Mitered Corners

Mitered borders work well when the border fabric is striped or plaid.

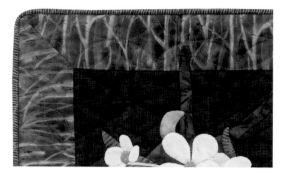

If the border fabric has an obvious direction, like the fabric used in the border of the "Cherry Blossom" cushion (page 61), you will probably find that it looks better if you miter the corners.

1. Before starting, you need to determine the finished dimensions of the project top to which you will be adding the borders. Measure the width of the piece near the top edge, through the horizontal center, and near the bottom edge. If these three measurements are within ¼" of each other, make a note of the center measurement and continue with step 2. If not, you may need to rework the piece a bit to make it more square.

2. Measure the length of the project top near the left and right edges and through the vertical center. Again, square up the piece if the measurements are not within ¼" of each other. Make a note of the center measurement.

3. Subtract ½" from the width and length measurements determined in steps 1 and 2. These numbers are the finished width and length of the project top.

4. Add twice the *finished* width of the border to the *finished* width of the project top. *Do not* add seam allowances to these numbers. Then add 1¼", the amount that will give you the seam allowance needed for mitering. This number is the length of the strips you need to cut for the top and bottom of the project. For example, if your project measures 42" wide *finished*, without the border, and you want to attach a 3"-wide mitered border, calculate the length of the strips as follows:

Length of strip = 42" + (2 x 3") + 1¼" = 49¼"

5. Fold the strips in half, right sides together, aligning the ends. Position the 45° mark of your rotary-cutting ruler along the long edge of the fabric, with the corner of the ruler at the corner of the fabric. Cut along the edge of the ruler.

6. Repeat step 4 with the finished length measurements to calculate the length of the side borders. Trim them as indicated in step 5.

7. On the front of the project top, use an air- or water-soluble marker to make a mark ¼" from each corner. On the wrong side of each border strip, make a mark ¼" from the corners of each short side.

8. Sew the borders to the piece, matching the marks. It does not matter in which order you add the strips. Sew only from mark to mark, backstitching at the beginning and end of the seam.

9. At each corner, place the two adjoining strips right sides together, aligning the ends. Beginning at the marked point, backstitch and sew the strips together along the angled end. Press the seam allowances open. Press the seam allowances that join the borders to the project toward the borders.

Preparing the Quilting Sandwich

Before you can quilt your project, you must layer the cushion or wall-hanging top with batting and backing. These layers are often called the quilt "sandwich." For cushions, the backing will be enclosed in the pillow and will not be seen; plain fabric will work fine. Any quilting fabric that coordinates with the front and will not show through to the front will work fine for wall hangings.

1. Cut the backing fabric so that it is about 1" larger than the project top on each side. Cut the batting so that it is about ¼" larger than the top on each side. Iron the backing fabric and project top to remove any wrinkles.

2. Lay the backing fabric on a smooth surface, wrong side up. Using masking tape, tape at intervals around the edges so that the backing lies flat. It should be taut but not stretched.

3. Center the batting on top of the backing, and carefully smooth out all wrinkles.

4. Lay the project top on the batting, right side up. Use a ruler to make sure that the corners are square. Then use long basting stitches around the edges, checking as you go to make sure that the top is square.

5. Use small, rustproof safety pins or long basting stitches to baste the remainder of the sandwich together, working in straight lines parallel to the borders to keep your work squared.

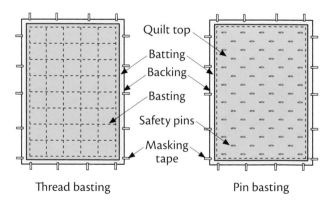

6. Remove the tape. Your sandwich is ready to quilt.

Quilting

One of the things that I like most about hand appliqué is the dimensional effect created by the seam allowances padding the edges of the pieces. This effect can be further enhanced with quilting. At a minimum, I usually outline quilt around the appliqué pieces. Use a thread color that matches either the background fabric or the appliqué pieces, or, if you will be machine quilting over areas with many fabric colors and don't want the thread to be too obvious, clear monofilament is a good choice.

Quilting can also be used to add detail, such as leaf veins and stamens. When adding detail quilting, you may find it helpful to plan the quilting lines in advance. Make a scale drawing of your project and use colored pencil to mark the quilting lines. Modifications are easy to make at this stage because no stitching has been done. When you are happy with the quilting plan, mark the quilting lines on the fabric and quilt away. Cotton, rayon, and other decorative threads are good for enhancing detail quilting.

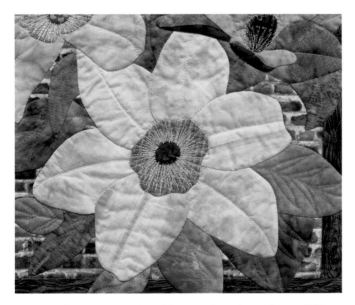

Detail quilting in the "Clematis" cushion (page 97)

If you prefer, as I do, not to mark directly onto the fabric, you may wish to trace your quilting pattern onto a tear-away product and then use that product to mark the quilting lines. After drawing the pattern, position the traced pattern onto the top and then quilt following the drawn lines. After the quilting is completed, the tear-away product is easily removed. One product that I particularly like to use for this is Glad Press'n Seal. It is transparent, so you can easily trace the pattern and also see the appliqué pieces while you stitch.

It sticks to the fabric (with the additional bonus of stabilizing it) and is easy to remove once the quilting is completed. Use tweezers to remove any small pieces that might remain in the stitching.

Some ideas for background and border quilting are given here. When you are finished quilting, snip all thread ends, or thread a needle with the ends and hide them in the quilt sandwich. Trim the excess batting and backing even with the edges of the top.

Background Quilting

The areas behind the appliqué pieces are often big enough that they benefit from some quilting. With the projects in this book, the appliqué is always the star of the show, so I prefer the quilting to play a supporting role and avoid more complex designs. The following are some ideas for the background.

Cross-hatching. Cross-hatching provides a nice, consistent background that complements the shapes of the appliqué pieces. It looks best on these projects when it is only on the background and does not continue over the appliqué pieces. The only disadvantage is that you have to either frequently start and stop quilting lines, or stitch over lines that have been previously quilted. I prefer the latter option, because the edges of the appliqué pieces create a shadow that obscures this extra stitching. Cross-hatching is often done at 90° angles, which creates a background of squares, but you can also use a 60° angle to create diamonds.

Cross-hatched diamond quilting in the "Cherry Blossom" cushion (page 61)

To create successful cross-hatching, I find that I get the best results by marking the lines with masking tape. If the tape is the same width as the interval between lines, you can mark two lines at a time with each piece of tape. You will not have to mark any lines on the fabric; you can adjust the tape if necessary before starting to quilt, and you can wait until after the layers have been basted to position the tape. However, to avoid sticky residue on your fabric, make sure that you do not apply the tape until you are ready to quilt, and do not leave it on the fabric for more than a day or two. For the projects in this book, I used 1"-wide masking tape for the cross-hatching. Tape and stitch all the lines in one direction first, and then remove the tape before you tape and stitch the lines in the other direction. This prevents stitching across the tape and makes removal of the tape much easier.

Free-motion quilting. Any meandering free-motion quilting, such as stippling, can be used to fill in the background. The advantage to a meandering technique is that you don't have to start and stop often, if at all. It also provides a nice background to allow the appliqué to stand out.

Border Quilting

The simplest quilting for the borders of these projects is parallel lines. If your border fabric has a pattern, quilting in the border simply will not show up very well, so straight lines provide a neat, clean finish with little effort. You can either use the presser foot as a guide for the distance between lines, or use masking tape to mark the lines.

For some of the projects, if the design of the border fabric was subtle enough for the quilting to be visible, or when I wanted to quilt with a thread that contrasted with the fabric, I quilted the border with simple patterns, like the ones shown on page 28. A uniform, repeated pattern along the border provides a neatly finished look.

Border quilting on the "Petunia" wall hanging (page 35).
A relatively low-contrast print allows
a fancy quilting motif to shine.

Free-motion quilting on the
"Cherry Blossom" wall hanging (page 61)

Enlarge as necessary to fit your border.

Cushion Finishing

Once your project is quilted, turning it into a cushion is easy to do simply by adding a back and a pillow form. Instructions for two reclosable backs are given here, along with instructions for piping the cushion edges, which provides a nice finishing touch for your beautiful appliqué work.

Creating a Back

When choosing a backing fabric, select one that complements the cushion front. I often use silk dupioni for the back because it provides a nice contrast to the front and looks elegant. The fabric can be washed, but it does shrink about 5" per yard when it is washed the first time and it will lose some of its shine, so wash it before you make your cushion, following the manufacturer's instructions.

A one-piece back is always an option, but you must take out stitching every time you want to remove the pillow form to wash the pillow cover. A reclosable back is an easy alternative. I've given instructions for two options below.

Overlapped Back

In this method, two pieces of fabric overlap each other, creating a hidden opening for inserting and removing the pillow form.

1. Cut the backing fabric to the same width as the cushion front (including the seam allowance), but 7" longer. For example, if your cushion front measures 16½" square, cut a piece of fabric 16½" x 23½" for the back.

2. Cut the back fabric across the width at roughly one-third the length so that you have two pieces.

3. Make a ¼" hem on the cut edges of each piece.

4. With wrong sides up, lay the longer rectangle on top of the shorter rectangle with the hemmed edges overlapping to create a piece that measures the length of the unfinished cushion top. Baste the pieces together along the overlapped edges.

Zippered Back

There are numerous ways to install a zipper, and often the zipper packaging will contain instructions. However, the following are basic instructions that you can use.

1. Cut the backing fabric to the same width as the cushion front (including seam allowance), but 2" longer. For example, if your cushion front measures 16½" square, cut a piece of fabric 16½" x 18½" for the back.

2. Cut the back fabric across the width approximately where you want the zipper to be. It can be centered, in which case the fabric should be cut in half.

3. With right sides together, use a ⅝" seam allowance to baste the pieces back together along the edges you just cut. Press the seam allowance open.

Nice and Neat

If you want to be able to hide the slider after the cushion is complete, or if your zipper is a bit too short, you can use a fabric tab. Cut an additional piece of the backing fabric, 1½" x 4". Fold the fabric strip in half, wrong sides together, so that it measures 1½" x 2". Position the piece so that it is centered over the basted zipper seam, with the raw edges even with the edge of the backing piece and the folded side toward the center. When positioning the zipper, place the edge of the zipper pull against the folded edge of the fabric tab rather than all the way to the edge. Baste in place slightly less than ¼" from the cushion edge. Then continue with the zipper installation.

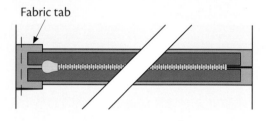

Fabric tab

4. Place the zipper face down on the seam, with the coil centered on the seam line. Using a very long basting stitch, baste both long sides of the zipper to the fabric, following the stitching guideline on the zipper tape. I prefer to do this step by hand, but it can be done by machine.

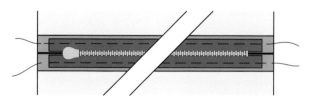

5. Unzip the zipper part of the way to begin stitching so that you do not have to stitch next to the slider. You may have to remove some of the basting stitches from step 3 to move the slider. Stitching from the right side of the fabric and using a zipper foot, topstitch one side of the zipper, maintaining an even distance from the seam. As you get close to the slider, stop with the needle down

and raise the presser foot. Move the slider back up to close the zipper. Continue topstitching until you get just past the bottom stop.

6. Turn the piece 90° and topstitch across the bottom of the zipper. Turn the piece 90° again and topstitch the remaining side, moving the slider out of the way as necessary.

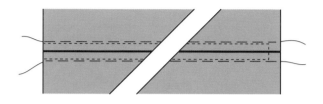

7. Remove the basting stitches from the zipper and the seam allowance. Measure the pillow front and trim the back to the same size.

Help Line

It looks best if the topstitching is the same distance from the opening on both sides of the zipper and in a reasonably straight line. To accomplish this, use ¼"-wide masking tape to mark where the topstitching should be. Then just stitch along the edge of the masking tape and remove it when you're done.

Adding Piping

Piping can add a nice finished edge to your cushion. It is made by wrapping fabric around a length of cording. I usually use ¼"-diameter cotton cording, but you may use a slightly thicker cording if you wish. Just check to be sure that the fabric strip will wrap around the cording and leave at least a ¼" seam allowance. Preshrink cotton cording before making your piping. If you have a piping foot for your machine, this makes applying the piping easier, but a zipper foot will also work.

1. Cut 1¼"-wide strips of fabric for covering the cording. For a square cushion, you can cut straight-grain strips, but if the cushion is round, you will need to cut bias strips (see page 21).

2. Join strips as shown to make a length sufficient to go around the cushion plus about an extra 3". Press the seam allowances open.

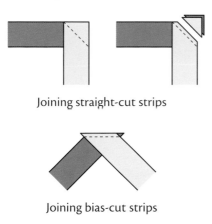

Joining straight-cut strips

Joining bias-cut strips

3. With the right side of the fabric facing out, fold the strip around the cording, aligning the raw edges, and pin it in place. Baste close to the cording along the length of the strip. If you are using a piping foot, slide the cording under the groove of the foot with the raw edges of the fabric to the right. If you are using a zipper foot, have the needle to the left of the foot so that it can stitch as close to the cotton cording as possible.

4. Trim the seam allowance ¼" from the basting stitches. Rather than trying to balance the ruler on the piping, it is easier to determine the amount to trim off and then lay the ruler across the raw edges and cut.

5. Leaving about 1" loose at the beginning, pin the piping along the edges of the right side of the cushion top, aligning the raw edges.

For a square cushion: Begin at the center of the bottom edge and pin the piping in place until you are close to the first corner. Clip the seam allowance ¼" from the corner. This allows you to turn the corner. Turn the piping at the corner as shown in the illustration and continue pinning. Repeat at each corner.

Cushion top

For a round cushion: Begin at the bottom and pin around the top. If necessary, clip the piping seam allowance as you go to allow the piping to lie flat around the curve.

6. When you reach the starting point, trim the piping 1" beyond the beginning. Rip out 1" of the basting stitches at the end of the piping and fold back the unstitched fabric. Cut the end of the exposed cording so that it meets the beginning of the cording. Unfold the turned-back fabric and turn it under about ½" to create a finished edge. Wrap the folded edge around the starting end of the piping.

7. Using a piping or zipper foot, baste around the edge of the cushion, following the previous line of stitching.

Assembling the Cushion

Once the front is completed and any optional piping has been added, you are ready to stitch the cushion together. If you plan on adding a label to your cushion, attach it to the wrong side of the cushion back before the front and back are stitched together. Refer to "Attaching a Label" on page 33 for specifics. If the back has a zipper, partially open it. Lay the back over the front, right sides together. Pin, starting in the middle of the sides and working toward the corners. Stitch around the cushion, using a ¼" seam allowance. If the cushion has piping, you can either use a piping foot to stitch close to the piping, or stitch just to the outside of the piping with a zipper foot. After stitching, trim any excess fabric in the seam allowance, cutting the corners at an angle. Turn the pillow cover to the right side and insert the pillow form through the opening.

Wall-Hanging Finishing

The only tasks left to do to finish your wall hanging are adding a hanging sleeve, binding the edges, and attaching a label.

Making a Hanging Sleeve

A hanging sleeve will help you display your project on a wall. It can be made from muslin, the backing fabric, or any other fabrics you used in your wall-hanging top.

1. Determine the desired finished width of the sleeve. For the projects in this book, a 3"-wide sleeve should be more than adequate.

2. Cut a strip of fabric twice the finished width of the sleeve plus ½". Cut the length 1" shorter than the finished width of the wall hanging.

3. Hem the short ends by folding under approximately ⅜" twice. Stitch ¼" from the first fold.

4. Press the strip in half lengthwise, wrong sides together and raw edges aligned.

5. Center the sleeve on the back of the wall hanging, aligning the raw edges with the top edge of the wall hanging. Baste ¼" from the raw edges through all layers.

6. Add the binding as instructed below. The sleeve raw edge will be enclosed in the binding.

7. Hand blindstitch the bottom of the sleeve to the backing of the wall hanging, making sure the stitches do not go through to the front.

Binding

The fabric you use for the binding can be the same fabric as the border, or it can be a different fabric that complements the piece. Try to avoid bright colors, though, because they will draw the eye away from the quilt center.

1. Cut straight-grain binding strips as instructed for the project. Join the strips in the same manner as straight-grain strips for piping (see page 31) to make one long piece.

2. Press the binding strip in half lengthwise, wrong sides together.

3. With raw edges aligned, place the binding strip at about the center of the wall-hanging bottom edge. "Walk" the binding around the wall hanging to see whether any of the joining seams will end up at a corner. If they do, move the starting point of the binding so that this no longer occurs. With your walking foot, begin stitching the binding to the wall hanging, leaving about 4" at the end of the binding unstitched. Use a ¼" seam allowance. When you are ¼" from the first corner, angle the stitching into the corner. Clip the threads and remove the wall hanging from under the presser foot.

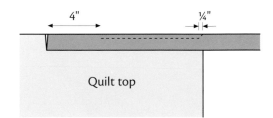

4. Fold the binding up so that the fold makes a 45° angle, and then fold the binding back down onto itself so that the raw edge is aligned with the quilt raw edge. Starting at the binding folded edge, stitch the binding to the next side of the wall hanging. Repeat for each corner.

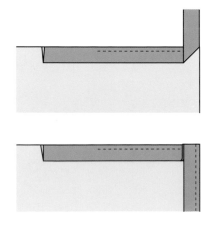

5. Stop sewing about 8" from the starting point. Open up the ends and fold them back at a 45° angle until the folds meet. Mark or finger-press the folds. Open up the folds and with right sides together, align the diagonal lines. Lift the binding away from the quilt and stitch on the line. Make sure that the binding fits the unstitched space and then trim the seam allowance to ¼" and press it open. Refold the binding and stitch it in place.

6. Fold the binding to the back of the quilt and hand blind-stitch it in place, mitering the corners.

Attaching a Label

A label is always a nice addition to your project, particularly if you have made the project as a gift. At a minimum, the label should contain the maker's name, location, date of completion, and washing instructions. Most labels are appliquéd to the back of the project after it is completed, but you can also piece the label into the backing or stitch it to the backing before the wall hanging is done, making it a more permanent part of the project. You can also add it after the quilting is complete but before the binding is applied. If you choose this method, baste the label in place in a corner of the wall hanging and appliqué just the two edges that will not be enclosed in the binding.

Flower boxes outside a pub, Harrogate, England.
Photo by Jonathan Propst.

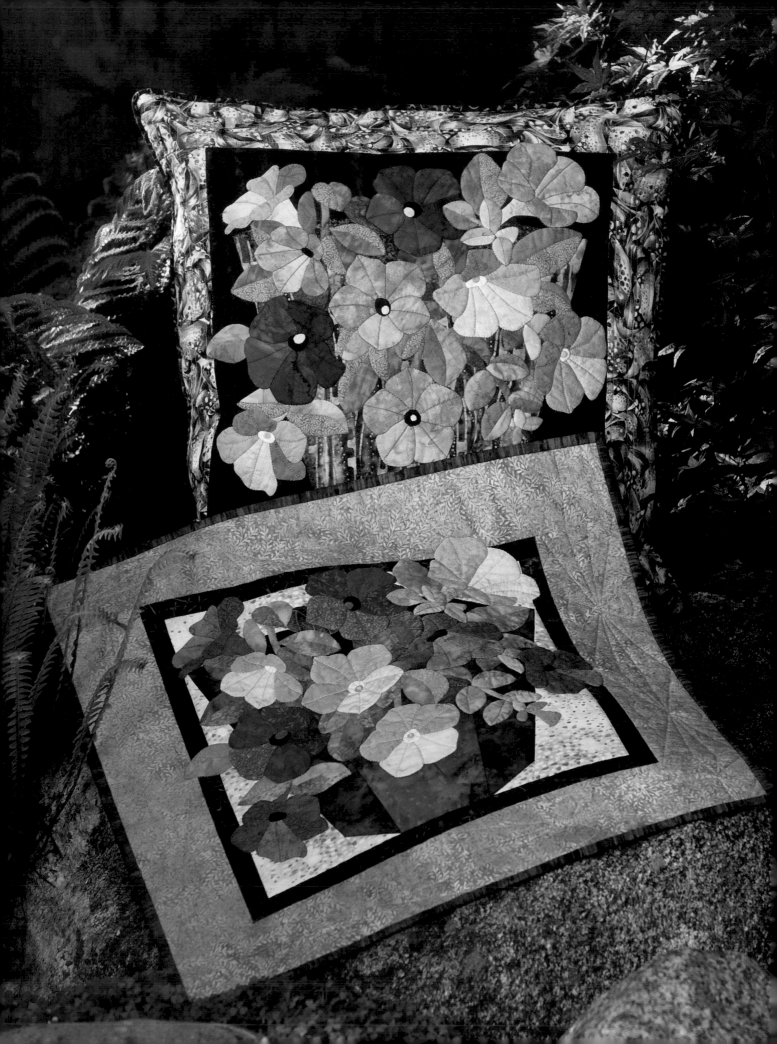

Petunia

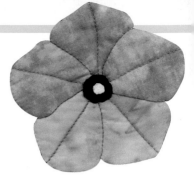

Cushion finished size: 19½" x 19½"
Wall-hanging finished size: 20½" x 20½"

Spring is a riot of color in the English town of Harrogate, where I live. Flowers appear everywhere, and as the season turns to summer, many of the local buildings feature window boxes and freestanding pots overflowing with petunias. Usually, like miniature gardens, there are a variety of colors mixed in each flowerpot. I thought it would be fun to stitch the petunias "growing" in a flowerpot. You can have a lot of fun selecting fabric for the container. If you have a fabric that is lighter in one area or on the reverse side, you can use the lighter area for the middle section and the darker fabric for the sides to add dimension.

Materials
Yardages are based on 42"-wide fabric.

Cushion
¼ yard of print for border

1 fat quarter of dark brown batik for background

1 fat quarter of brown striped batik for outer flowerpot

⅛ yard of fabric for piping

Scrap of medium brown fabric for inner flowerpot

Scraps of at least 7 different green fabrics for leaves and stems (refer to the color key on page 37 for specifics)

Scraps of at least 9 different lilac, lavender, and purple fabrics for flowers (refer to the color key on page 37 for specifics)

Scraps of very pale green, white, and very pale purple fabrics for flower centers

Scrap of very pale lilac or pale green fabric for flower bases

22" x 22" square of fabric for backing

⅝ yard of fabric for overlapped or zippered back

21" x 21" square of batting

2½ yards of cording

20" zipper to match cushion back (for zippered back only)

Plastic or vinyl for overlay

Freezer paper

Wall Hanging
⅓ yard of light blue batik for outer border

1 fat quarter of light mottled print for background

1 fat quarter of medium blue fabric for outer flowerpot

1 fat quarter of medium-dark blue fabric for outer flowerpot

⅛ yard of dark blue batik for inner border

Scrap of very dark brown fabric for inner flowerpot

Scraps of at least 7 different green fabrics for leaves and stems (refer to the color key on page 37 for specifics)

Scraps of at least 8 different mauve, pink, and purple fabrics for flowers (refer to the color key on page 37 for specifics)

Scraps of pale green, pale eggplant, dark rose, and white fabrics for flower centers

Scrap of rose or light green fabric for flower bases

Scrap of black fabric for flower centers

¼ yard of fabric for binding

22½" x 22½" square of fabric for backing

21½" x 21½" square of batting

Plastic or vinyl for overlay

Freezer paper

Cutting

All measurements include ¼"-wide seam allowances.

Cushion
From the background fabric, cut:
❖ 1 square, 14½" x 14½"

From the border fabric, cut:
❖ 2 strips, 3¼" x 14½"
❖ 2 strips, 3¼" x 20"

Wall Hanging
From the background fabric, cut:
❖ 1 square, 13" x 13"

From the inner-border fabric, cut:
❖ 2 strips, 1¼" x 13"
❖ 2 strips, 1¼" x 14½"

From the outer-border fabric, cut:
❖ 2 strips, 3½" x 14½"
❖ 2 strips, 3½" x 20½"

From the binding fabric, cut:
❖ 3 strips, 2¼" x 42"

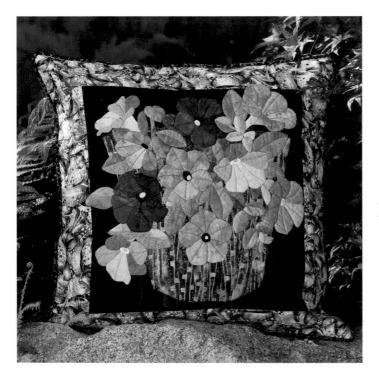

Constructing the Cushion or Wall-Hanging Top

Refer to "The Appliqué Process" on page 17.

1. Use the patterns on pages 38–41 to make a complete pattern. Trace the complete pattern onto plastic or vinyl to make the overlay.

2. Use the pattern to make freezer-paper templates for the appliqués. Refer to the color key on page 37 to make the appliqués from the fabrics indicated.

3. Refer to "Adding Borders" on page 23 to sew the borders to the background square, using the butted-corner method. *For the cushion,* add the 3¼"-wide border strips. *For the wall hanging,* add the 1¼"-wide inner-border strips to the background square, and then add the 3½"-wide outer-border strips.

4. Appliqué pieces 1–4 to make the flowerpot unit. Appliqué the flowerpot unit to the background.

5. Appliqué the following pieces together to make units: 12 and 13; 14 and 15; 16 and 17; 18 and 19; 21 and 22; 23 and 24; 26 and 27; 29 and 30; 31 and 32; 33 and 34; 35 and 36; 38 and 39; 40 and 41; 46 and 47; 51 and 52; 53 and 54; 55 and 56; 57 and 58; 60 and 61; 62 and 63; 66 and 67; 118 and 119; 120 and 121; 123 and 124; 125 and 126.

6. Appliqué pieces 5–58 to the background, stitching in numerical order.

7. Baste the bottom of piece 59 in place. Appliqué pieces 60–63 to the background. Appliqué the remainder of piece 59 to the background.

8. Appliqué pieces 64–142 to the background in numerical order, omitting pieces 140–142 for the wall hanging.

9. Remove all the freezer-paper templates.

Finishing

1. Layer the appliquéd top with batting and backing; baste the layers together.

2. Quilt as desired.

3. Refer to "Cushion Finishing" on page 29 or "Wall-Hanging Finishing" on page 32 for the appropriate instructions to finish your quilted piece.

Petunia Color Keys

Cushion

Fabric color	Piece(s)
Green 1 (lightest)	44, 50, 121, 122, 123, 126
Green 2	16, 23, 27, 32, 39, 40, 43, 45, 46, 49, 54, 57, 119, 120, 124, 125
Green 3	12, 14, 17, 35, 38, 41, 47, 51, 53, 55, 58, 65, 66, 118
Green 4	8, 13, 15, 18, 21, 24, 26, 29, 31, 34, 36, 52, 61, 63, 67
Green 5	7, 11, 19, 22, 30, 33, 48, 60, 62
Green 6 (darkest)	5, 6, 9, 10, 20, 56
Stem green	28, 37, 59
Lilac 1 (lightest)	79, 94, 112, 114, 133
Lilac 2	80, 81, 93, 95, 113, 115, 134, 136, 137
Lilac 3 (darkest)	82, 83, 92, 96, 116, 135
Lavender 1 (lightest)	74, 75, 85, 86, 105, 109, 127, 128
Lavender 2	76, 77, 78, 87, 88, 89, 106, 107, 108, 129, 130, 131
Purple 1 (lightest)	69, 73, 100
Purple 2	72, 99, 101
Purple 3 (darkest)	42, 70, 71, 98, 102
Very dark purple	90, 103, 110, 132, 138
White	84, 97, 117
Medium brown	1
Brown striped batik	2, 3, 4
Very pale purple	91, 111
Very pale lilac or green	25, 64, 68
Very pale green	104, 139, 140, 141, 142

Wall Hanging

Fabric color	Piece(s)
Green 1 (lightest)	41, 44, 50, 121, 122, 123, 125
Green 2	16, 23, 27, 32, 38, 43, 45, 46, 49, 54, 57, 119, 120, 124, 126
Green 3	12, 14, 17, 35, 39, 40, 47, 51, 53, 55, 58, 63, 65, 66, 118
Green 4	8, 13, 15, 18, 22, 24, 26, 29, 31, 34, 36, 52, 61, 62, 67
Green 5	7, 11, 19, 20, 21, 30, 33, 48, 60
Green 6 (darkest)	5, 6, 9, 10, 56
Stem green	28, 37, 59
Mauve 1 (lightest)	42, 79, 94, 112, 114, 133, 136
Mauve 2	80, 81, 93, 95, 113, 115, 134, 137
Mauve 3 (darkest)	82, 83, 92, 96, 116, 135
Pink 1	74, 75, 85, 86, 105, 109, 127, 128
Pink 2	76, 77, 78, 87, 88, 89, 106, 107, 108, 129, 130, 131
Purple 1 (lightest)	69, 73, 100
Purple 2	72, 99, 101
Purple 3 (darkest)	70, 71, 98, 102
Black	103, 138
White	90, 110, 132
Very dark brown	1
Medium blue	4
Medium-dark blue	2, 3
Pale green	91, 111
Rose or light green	25, 64, 68
Pale eggplant	104, 139
Dark rose	84, 97, 117

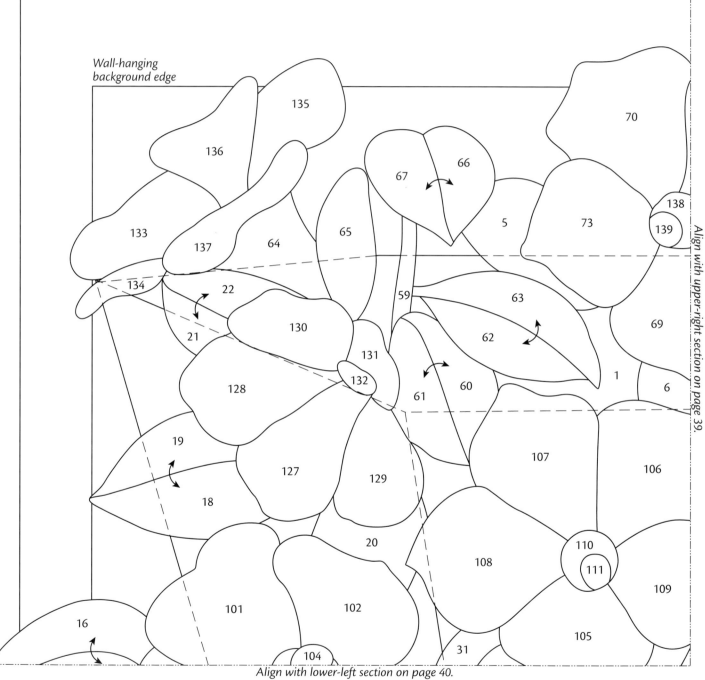

Cushion background edge

Wall-hanging background edge

Align with upper-right section on page 39.

Align with lower-left section on page 40.

Petunia appliqué pattern
Upper-left section

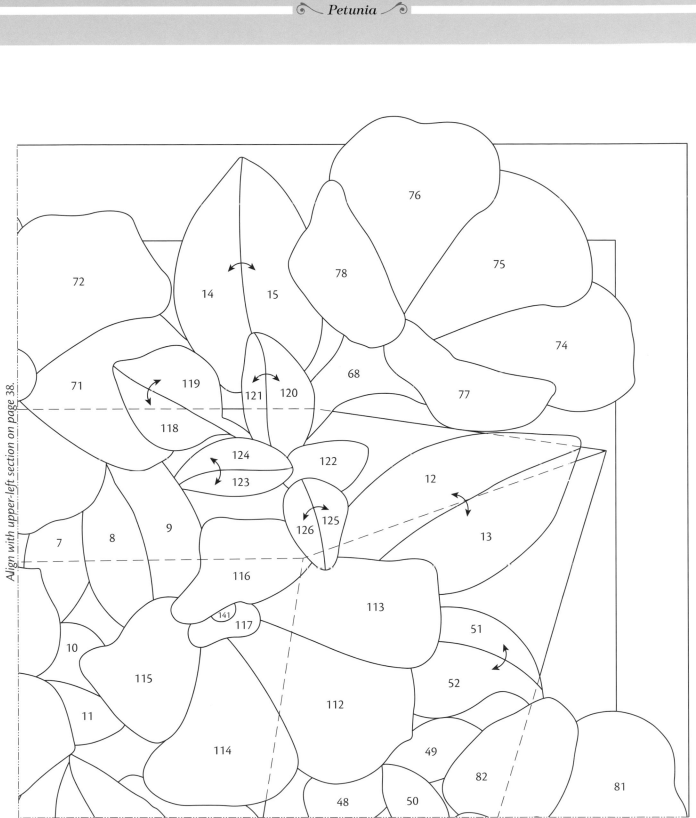

Align with upper-left section on page 38.

Align with lower-right section on page 41.

Petunia appliqué pattern
Upper-right section

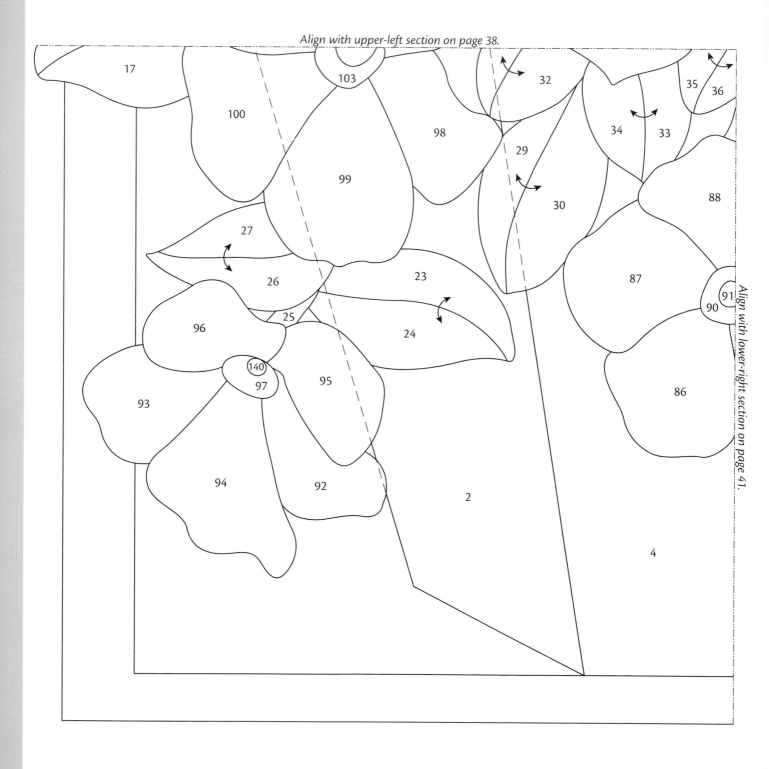

Align with upper-left section on page 38.

Align with lower-right section on page 41.

Petunia appliqué pattern
Lower-left section

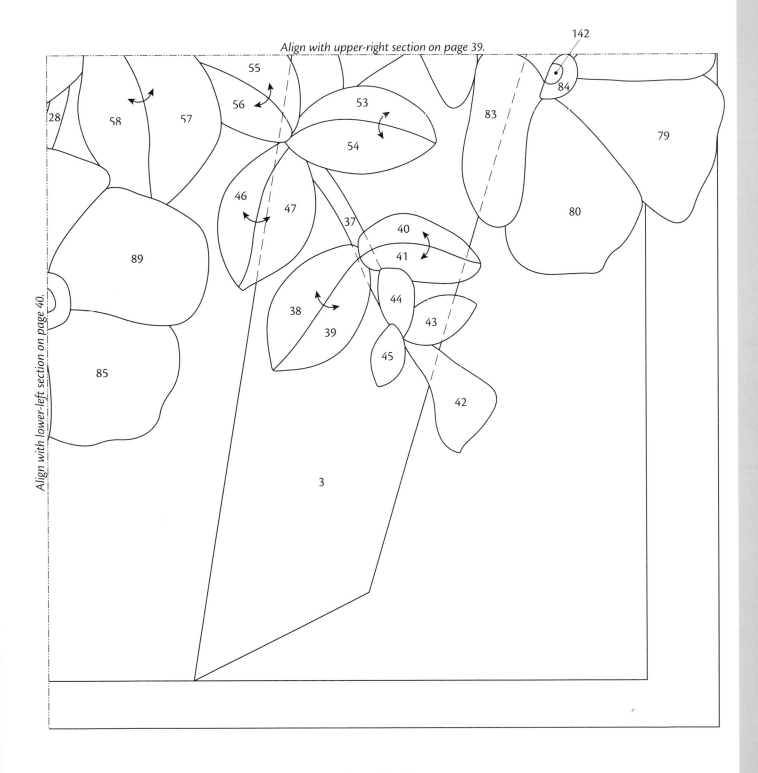

Petunia appliqué pattern
Lower-right section

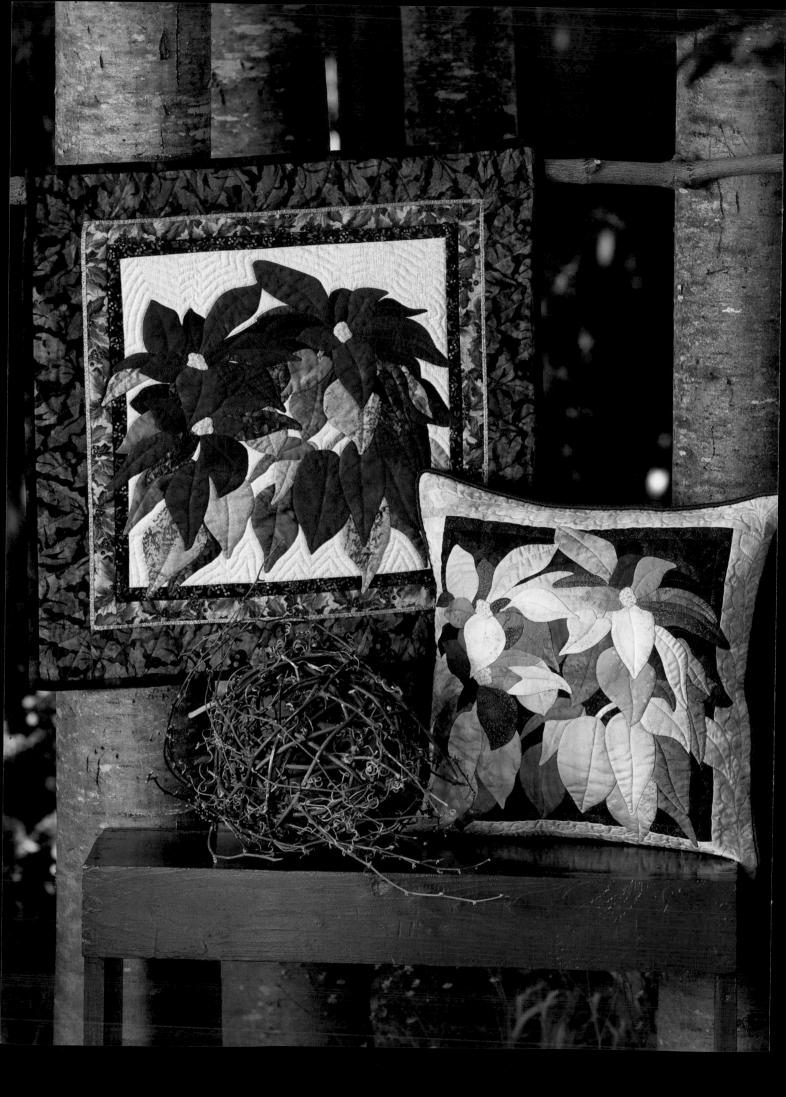

Poinsettia

Cushion finished size: 16" x 16"
Wall-hanging finished size: 20½" x 20½"

The poinsettia is not a flower that you will find growing outdoors in northern climates, but you will typically see these festive plants decorating homes and churches at Christmastime. I was pleasantly surprised to see them thriving outdoors in Portugal, where they grow into very large shrubs. For Christmas, the red coloration is popular, but the pink poinsettias are an attractive alternative.

Materials

Yardages are based on 42"-wide fabric.

Cushion

¼ yard of light batik for outer border

1 fat quarter of dark green fabric for background

⅛ yard of cranberry print for inner border

⅛ yard of fabric for piping

Scraps of at least 5 different green fabrics for leaves and stems (refer to the color key on page 45 for specifics)

Scraps of at least 10 different peach and pink fabrics for bracts (refer to the color key on page 45 for specifics)

Scrap of light green speckled fabric for flower centers

18½" x 18½" square of fabric for backing

Fabric for cushion back: ⅝ yard for overlapped back or 1 fat quarter for zippered back

17½" x 17½" square of batting

2 yards of cording

16" zipper to match cushion back (for zippered back only)

Plastic or vinyl for overlay

Freezer paper

Wall Hanging

¼ yard of green batik for outer border

1 fat quarter of ivory print for background

⅛ yard of light holiday print for middle border

⅛ yard of dark holiday print for inner border

Scraps of at least 4 different green fabrics for leaves and stems (refer to the color key on page 45 for specifics)

Scraps of at least 8 different red and peach fabrics for bracts (refer to the color key on page 45 for specifics)

Scrap of light green speckled fabric for flower centers

¼ yard of fabric for binding

22½" x 22½" square of fabric for backing

21½" x 21½" square of batting

2 yards of ³⁄₁₆"-wide gold ribbon for border trim (optional)

Plastic or vinyl for overlay

Freezer paper

43

Cutting

All measurements include ¼"-wide seam allowances.

Cushion

From the background fabric, cut:
- 1 square, 11½" x 11½"

From the inner-border fabric, cut:
- 2 strips, 1" x 11½"
- 2 strips, 1" x 12½"

From the outer-border fabric, cut:
- 2 strips, 2½" x 12½"
- 2 strips, 2½" x 16½"

Wall Hanging

From the background fabric, cut:
- 1 square, 13½" x 13½"

From the inner-border fabric, cut:
- 2 strips, 1" x 13½"
- 2 strips, 1" x 14½"

From the middle-border fabric, cut:
- 2 strips, 1½" x 14½"
- 2 strips, 1½" x 16½"

From the outer-border fabric, cut:
- 2 strips, 2½" x 16½"
- 2 strips, 2½" x 20½"

From the binding fabric, cut:
- 3 strips, 2¼" x 42"

Constructing the Cushion or Wall-Hanging Top

Refer to "The Appliqué Process" on page 17.

1. Use the patterns on pages 46–49 to make a complete pattern. Trace the complete pattern onto plastic or vinyl to make the overlay.

2. Use the pattern to make freezer-paper templates for the appliqués. Refer to the color key on page 45 to make the appliqués from the fabrics indicated.

3. Refer to "Adding Borders" on page 23 to sew the borders to the background, using the butted-corner method. *For the cushion*, add the 1"-wide inner-border strips to the background square, and then add the 2½"-wide outer-border strips. *For the wall hanging*, add the 1"-wide inner-border strips to the background square, followed by the 1½"-wide middle-border strips and then the 2½"-wide outer-border strips.

4. Appliqué pieces 1–52 to the background in numerical order.

5. Appliqué pieces 53, 54, and 55 together to make a unit. Appliqué the unit to the background.

6. Appliqué pieces 56–67 to the background in numerical order, omitting piece 61 for the cushion.

7. Remove all the freezer-paper templates.

8. *For the wall hanging*, if you are adding the gold ribbon, position it over the seam line between the middle and outer borders. Overlap the ends, folding under the end on top approximately ½". Stitch the ribbon in place with matching thread.

Finishing

1. Layer the appliquéd top with batting and backing; baste the layers together.

2. Quilt as desired.

3. Refer to "Cushion Finishing" on page 29 or "Wall-Hanging Finishing" on page 32 for the appropriate instructions to finish your quilted piece.

Poinsettia Color Keys

Cushion

Fabric color	Pieces
Peach	38, 46
Very pale pink	20, 35, 54, 57, 66
Pale pink	3, 18, 26, 50, 52
Light pink	16, 43
Medium pink 1	31, 36, 59, 62
Medium pink 2	19, 33, 58
Light magenta	29, 34, 49, 53, 56, 64
Magenta	2, 7, 23, 32, 47, 51
Cranberry	5, 25, 44, 63
Mauve	17, 21, 30, 39, 55, 65
Pale green	1, 4, 8, 45
Light green 1	14, 41
Light green 2	10, 13, 24, 28, 40
Medium green	9, 12, 22, 27, 42
Dark green	6, 11, 15, 48
Light green speckled	37, 60, 67

Wall Hanging

Fabric color	Pieces
Peach	38, 46
Red 1 (lightest)	26, 55, 57
Red 2	18, 35, 50, 52, 66
Red 3	16, 17, 31, 33, 36, 43, 58, 59, 62
Red 4	20, 39
Red 5	21, 30, 54, 65
Red 6	7, 23, 29, 32, 34, 47, 49, 51, 53, 56, 64
Red 7 (darkest)	3, 5, 19, 25, 44, 63
Light green 1	14, 41
Light green 2	1, 4, 8, 10, 13, 24, 28, 40, 45
Medium green	2, 9, 11, 15, 27, 42
Dark green	6, 12, 22, 48, 61
Light green speckled	37, 60, 67

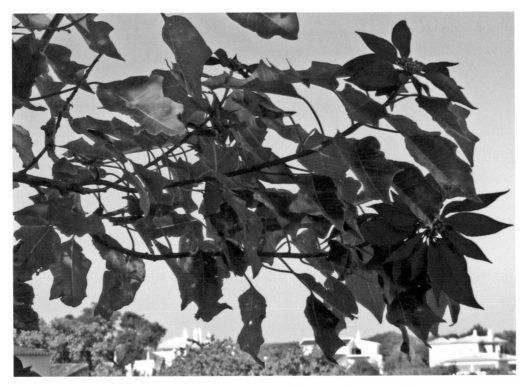

Poinsettia shrub, Portuguese coast. Photo by Jonathan Propst.

Wall-hanging background edge

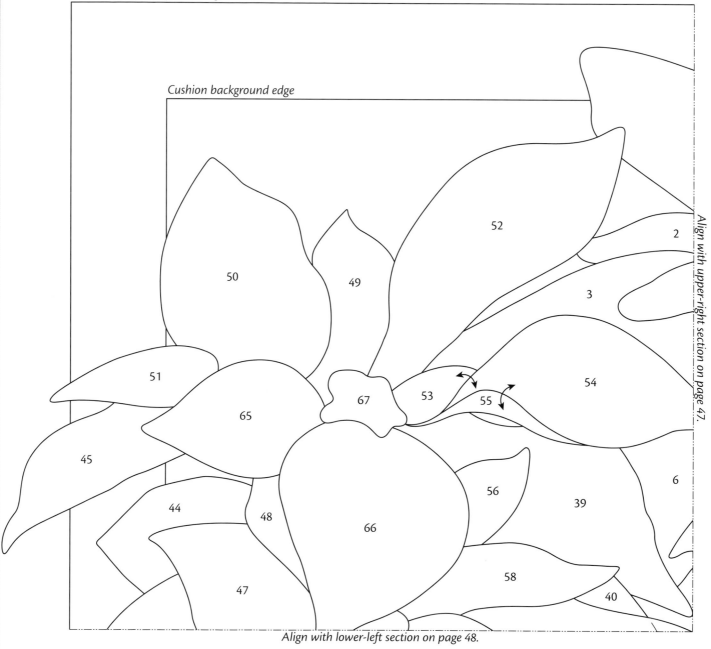

Cushion background edge

50

49

52

2

3

51

67

53

55

54

65

45

48

56

6

44

66

39

47

58

40

Align with upper-right section on page 47.

Align with lower-left section on page 48.

Poinsettia appliqué pattern
Upper-left section

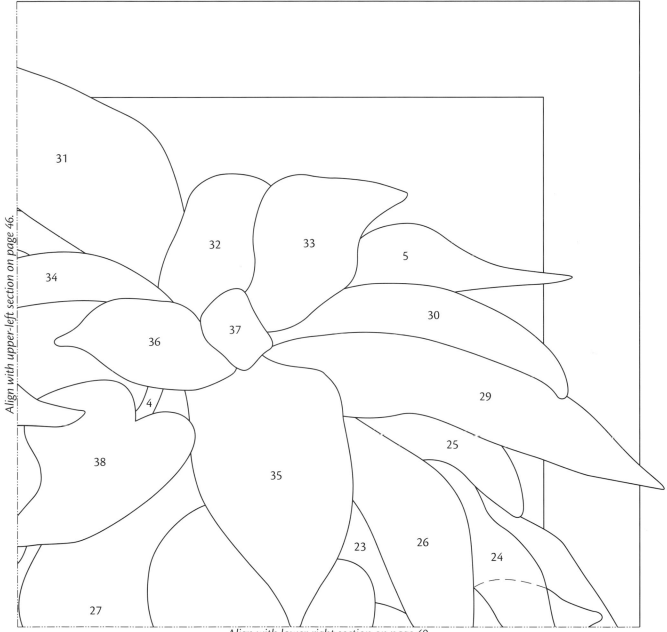

Align with upper-left section on page 46.

Align with lower-right section on page 49.

Poinsettia appliqué pattern
Upper-right section

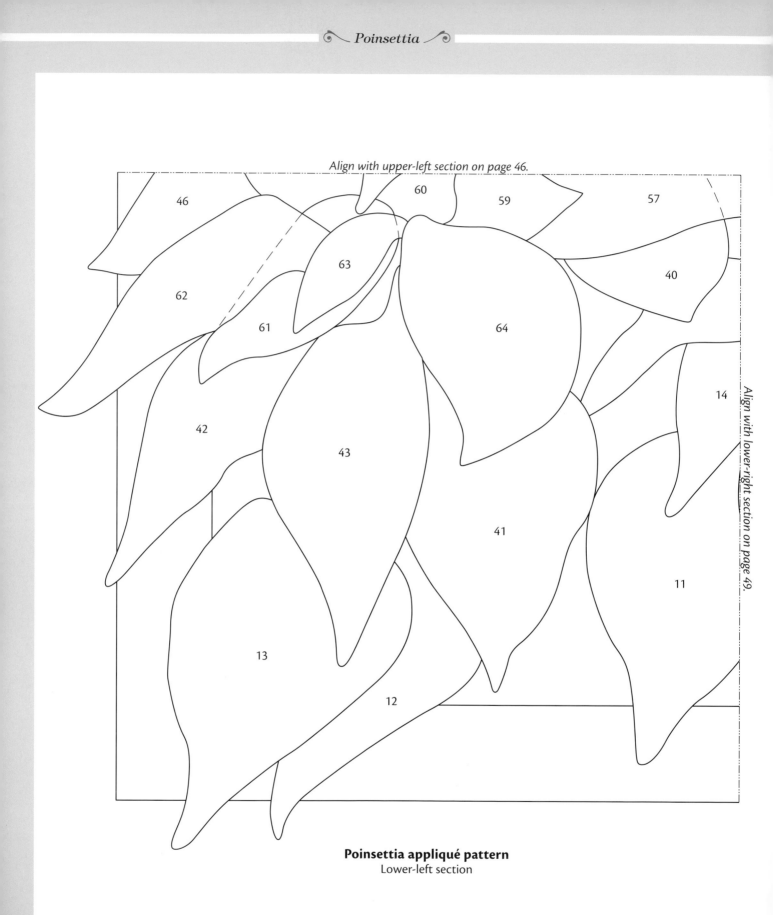

Align with upper-left section on page 46.

Align with lower-right section on page 49.

Poinsettia appliqué pattern
Lower-left section

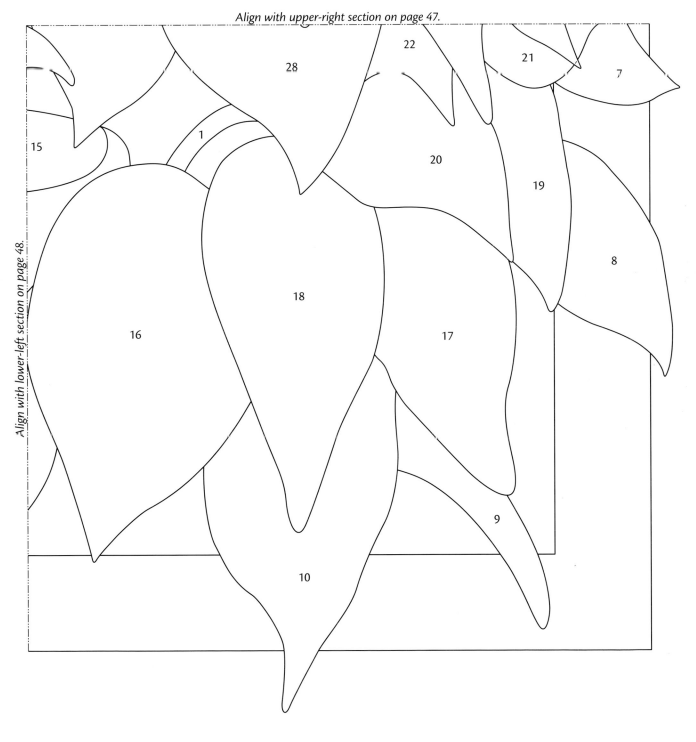

Align with upper-right section on page 47.

Align with lower-left section on page 48.

Poinsettia appliqué pattern
Lower-right section

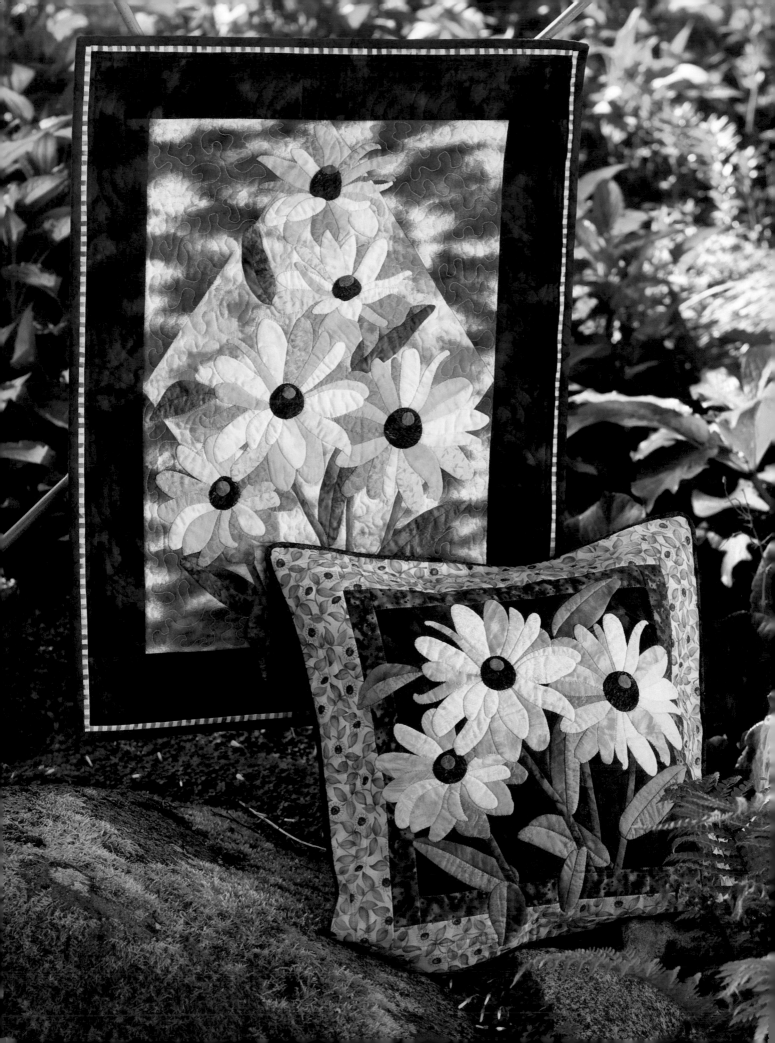

Black-Eyed Susan

Cushion finished size: 18" x 18"
Wall-hanging finished size: 20½" x 26½"

When I made this cushion, I had selected the colors largely based on the border fabric. My son, who was just about to leave to go to the University of Wyoming, and who hadn't previously shown particular enthusiasm for my quilts, got very excited and told me that the brown-eyed Susan was the basis of the school's brown and gold colors. I had inadvertently made the perfect cushion for my son to take with him to college.

Materials

Yardages are based on 42"-wide fabric.

Cushion

¼ yard of floral for outer border

1 fat quarter of brown fabric for background

⅛ yard of green print for inner border

⅛ yard of fabric for piping

Scraps of at least 3 different green fabrics for leaves and stems (refer to the color key on page 55 for specifics)

Scraps of at least 7 different yellow and gold fabrics for flowers (refer to the color key on page 55 for specifics)

Scrap of dark brown fabric for flower centers

Scrap of beige fabric for flower centers

20½" x 20½" square of fabric for backing

⅝ yard of fabric for overlapped or zippered back

19½" x 19½" square of batting

2⅛ yards of cording

18" zipper to match cushion back (for zippered back only)

Plastic or vinyl for overlay

Freezer paper

Wall Hanging

½ yard of light sky print for background

⅓ yard of dark blue fabric for border

1 fat quarter of dark sky print for background

⅛ yard of striped fabric for border accent

Scraps of at least 3 different green fabrics for leaves and stems (refer to the color key on page 55 for specifics)

Scraps of at least 8 different yellow and gold fabrics for flowers (refer to the color key on page 55 for specifics)

Scrap of dark brown fabric for flower centers

Scrap of beige fabric for flower centers

¼ yard of fabric for binding

22½" x 28½" rectangle of fabric for backing

21½" x 27½" rectangle of batting

Plastic or vinyl for overlay

Freezer paper

Cutting

All measurements include ¼"-wide seam allowances.

Cushion

From the background fabric, cut:
- 1 square, 11½" x 11½"

From the inner-border fabric, cut:
- 2 strips, 1½" x 11½"
- 2 strips, 1½" x 13½"

From the outer-border fabric, cut:
- 2 strips, 3" x 13½"
- 2 strips, 3" x 18½"

Wall Hanging

From the light sky print, cut:
- 1 rectangle, 14⅝" x 20⅞"

From the dark sky print, cut:
- 2 rectangles, 7¾" x 11"

From the border fabric, cut:
- 4 strips, 3½" x 20½"

From the border accent fabric, cut:
- 2 strips, 1" x 20½"
- 2 strips, 1" x 26½"

Constructing the Cushion Top

Refer to "The Appliqué Process" on page 17.

1. Use the patterns on pages 54 and 56–59 to make a complete pattern. Pay careful attention to the background edge marks. You will not be using the top two flowers. Trace the complete pattern onto plastic or vinyl to make the overlay.

2. Refer to the pattern, the color key on page 55, and "Making Bias Strips and Stems" on page 21 to make stem pieces 46, 54, 55, and 60. Cut the strips 1¼" wide for ¼"-wide finished stems. Also make stem piece 51, cutting the strip 1" wide for a ⅛"-wide finished stem.

3. Use the pattern to make freezer-paper templates for the appliqués. Refer to the color key on page 55 to make the appliqués from the fabrics indicated.

4. Appliqué the following pieces together to make units: 1 and 2; 47 and 48; 49 and 50; 52 and 53; 56 and 57; 58 and 59; 61 and 62; 101 and 102.

5. Appliqué pieces 46–48 and 51–55 to the background, stitching in numerical order.

6. Refer to "Adding Borders" on page 23 to stitch the border strips to the background, using the butted-corner method. Add the 1½"-wide inner-border strips to the background square, and then add the 3"-wide outer-border strips.

7. Appliqué pieces 1, 2, 49, 50, and 56–124 to the background, stitching in numerical order.

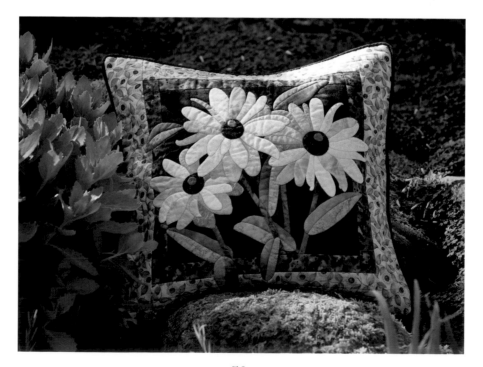

Black-Eyed Susan Color Keys

Cushion

Fabric color	Pieces
Very pale yellow 1	77, 80, 104, 107, 109, 121, 122
Very pale yellow 2	65, 76, 97
Pale yellow	66, 74, 78, 81, 87, 90, 96, 108, 113, 114, 115, 117, 120
Yellow 1	67, 70, 72, 75, 79, 86, 88, 89, 93, 95, 98, 105, 111, 112, 118, 119
Yellow 2	73, 106
Gold	63, 64, 69, 71, 92, 94, 103, 110, 116
Dark gold	68, 84, 85, 91
Medium-light green	2, 47, 49, 53, 57, 58, 62, 101
Medium green	1, 48, 50, 52, 56, 59, 61, 102
Stem green	46, 51, 54, 55, 60
Dark brown	82, 99, 123
Beige	83, 100, 124

Wall Hanging

Fabric color	Pieces
Very pale yellow	40, 121, 122
Pale yellow	15, 22, 25, 29, 34, 38, 39, 42, 77, 80, 104, 107, 109
Light yellow	7, 14, 16, 19, 35, 45, 66, 76, 78, 81, 87, 90, 97, 108, 113, 114, 115, 117
Medium-light yellow	30, 36, 65, 74, 96, 120
Yellow	8, 11, 13, 17, 20, 21, 33, 37, 41, 70, 72, 73, 75, 79, 86, 89, 93, 95, 98, 106, 111, 112, 118, 119
Gold yellow	9, 67, 88, 105
Gold	6, 10, 12, 18, 26, 27, 28, 31, 63, 64, 69, 71, 92, 94, 103, 110, 116
Dark gold	5, 32, 68, 84, 85, 91
Medium-light green	2, 4, 47, 49, 53, 57, 58, 62, 101
Medium green	1, 3, 48, 50, 52, 56, 59, 61, 102
Stem green	46, 51, 54, 55, 60
Dark brown	23, 43, 82, 99, 123
Beige	24, 44, 83, 100, 124

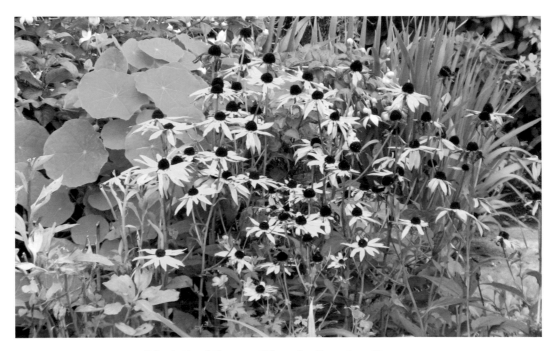

Black-Eyed Susans. Photo by Jonathan Propst.

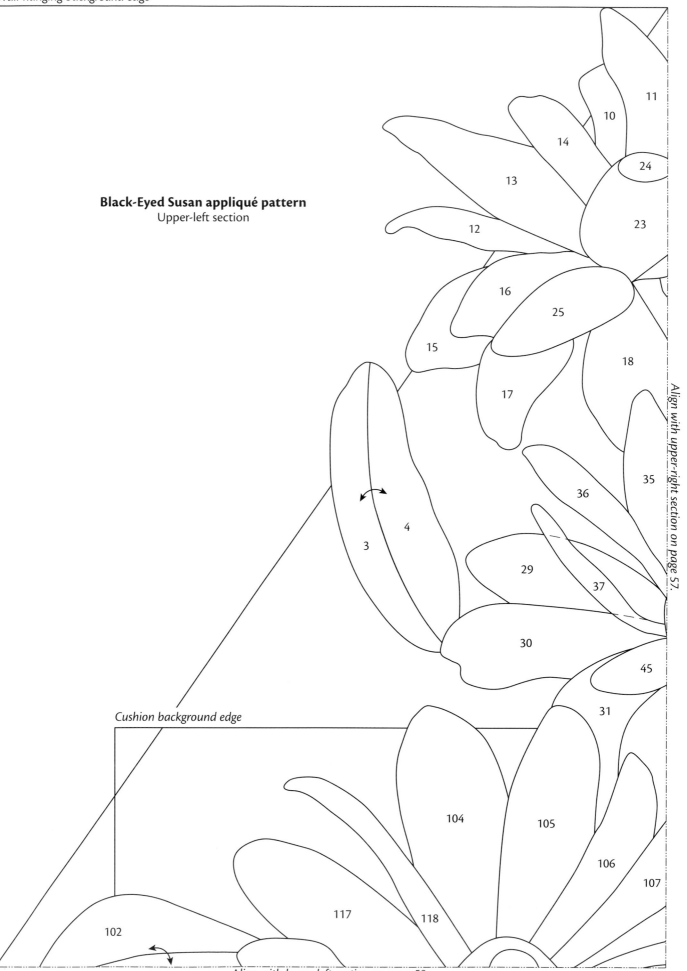

Black-Eyed Susan appliqué pattern
Upper-left section

11

10

14

24

13

12

23

16

25

15

17

18

35

36

4

3

29

37

30

45

31

Align with upper-right section on page 57.

Cushion background edge

104

105

106

107

117

118

102

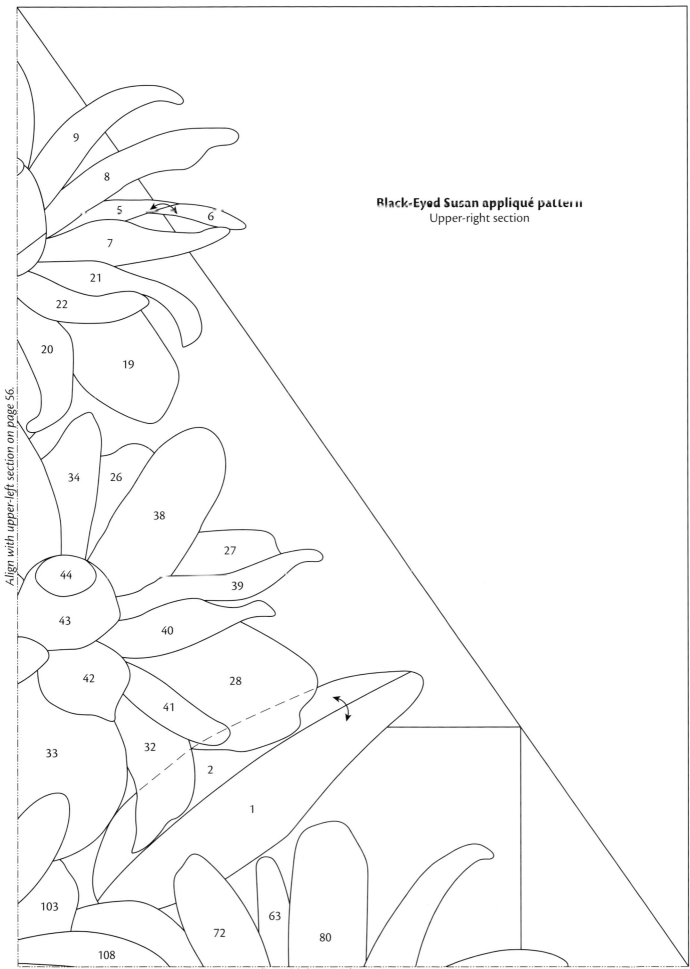

Black-Eyed Susan appliqué pattern
Upper-right section

Align with upper-left section on page 56.

Align with lower-right section on page 59.

101

119

124

123

116

121

122

114

115

120

111

112

87

86

88

84

110

95

100

99

96

85

89

97

90

94

93

98

92

91

48

55

52

53

59

60

58

56

**Black-Eyed Susan
appliqué pattern**
Lower-left section

*Complete patterns for
pieces 61 and 62
are on page 54.*

62

61

Align with lower-right section on page 59.

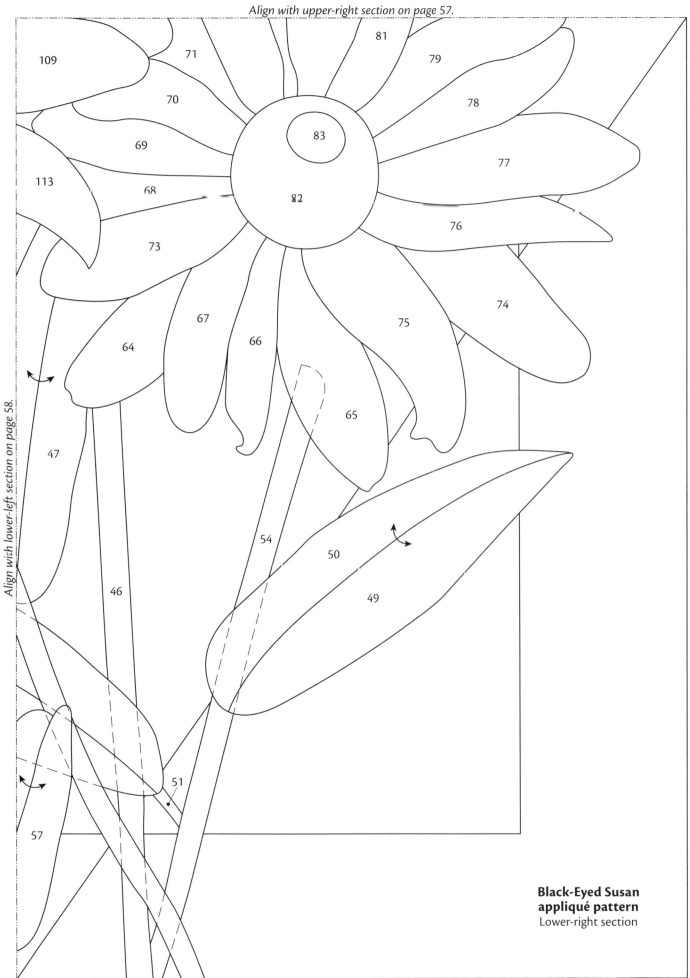

Align with lower-left section on page 58.

**Black-Eyed Susan
appliqué pattern**
Lower-right section

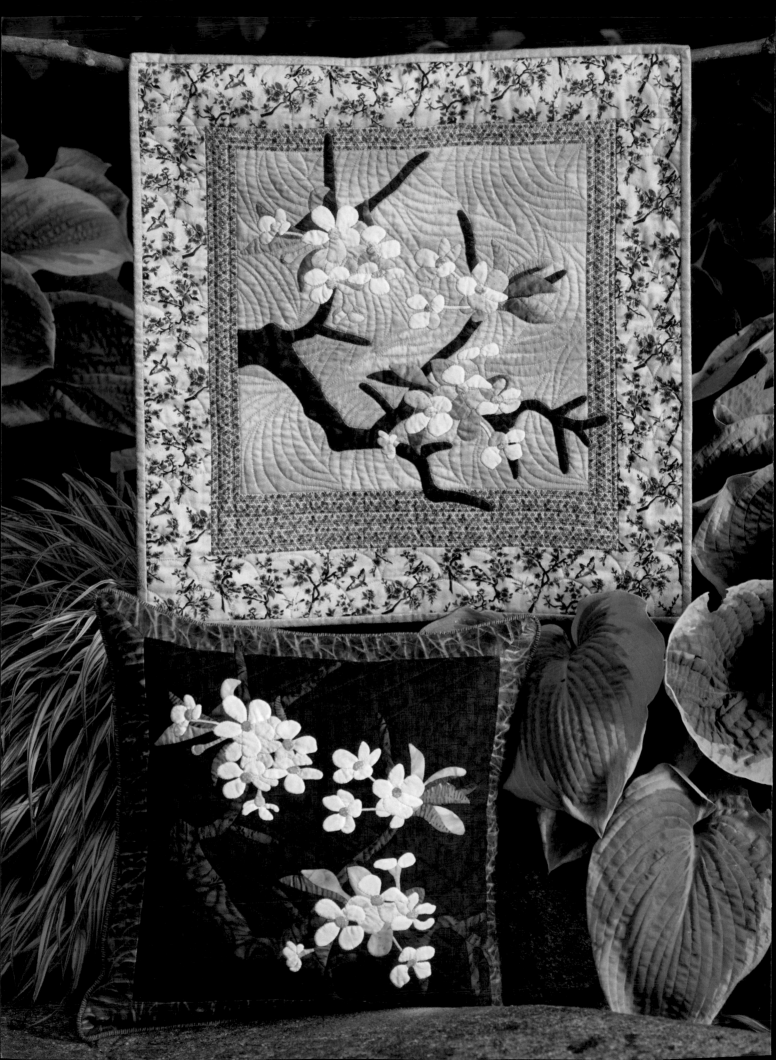

Cherry Blossom

Cushion finished size: 18" x 18"
Wall-hanging finished size: 23½" x 24½"

We have a small cherry tree growing in our back garden, and it produces just enough fruit to make one pie, if we can get the cherries before the birds eat them. But in the spring we are treated to the sight of the delicate ivory flowers that I've captured in this design. This pattern gives you the perfect opportunity to use some of those Asian fabrics that you may have collected. If you select pale colors for the flowers, be careful about the background fabric that you choose. The wall hanging uses a medium taupe background fabric that is just dark enough to allow the pale pink flowers to show.

Materials

Yardages are based on 42"-wide fabric.

Cushion

¼ yard of striped fabric for border

1 fat quarter of dark blue fabric for background

1 fat quarter of brown fabric for branches

⅛ yard of fabric for piping

Scraps of at least 4 different green fabrics for leaves and stems (refer to the color key on page 63 for specifics)

Scraps of at least 5 different ivory, pale yellow, and pale peach fabrics for flowers (refer to the color key on page 63 for specifics)

Scrap of green speckled print for flower centers

20½" x 20½" square of fabric for backing

⅝ yard of fabric for overlapped or zippered back

19½" x 19½" square of batting

2⅛ yards of cording

18" zipper to match cushion back (for zippered back only)

Plastic or vinyl for overlay

Freezer paper

Wall Hanging

⅜ yard of floral for outer border

¼ yard of geometric print for inner border

1 fat quarter of medium taupe fabric for background

1 fat quarter of brown fabric for branches

Scraps of at least 5 different green fabrics for leaves and stems (refer to the color key on page 63 for specifics)

Scraps of at least 5 different pink fabrics for flowers (refer to the color key on page 63 for specifics)

Scrap of green speckled print for flower centers

¼ yard of fabric for binding

25½" x 26½" rectangle of fabric for backing

24½" x 25½" rectangle of batting

Plastic or vinyl for overlay

Freezer paper

Cutting

All measurements include ¼"-wide seam allowances.

Cushion

From the background fabric, cut:

❖ 1 square, 15" x 15"

From the border fabric, cut:

❖ 4 strips, 2¼" x 19¼"

Wall Hanging

From the background fabric, cut:

❖ 1 square, 15" x 15"

From the inner-border fabric, cut:

❖ 2 strips, 1¾" x 15"
❖ 1 strip, 1½" x 17½"
❖ 1 strip, 3" x 17½"

From the outer-border fabric, cut:

❖ 2 strips, 3½" x 17½"
❖ 2 strips, 3½" x 23½"

From the binding fabric, cut:

❖ 3 strips, 2¼" x 42"

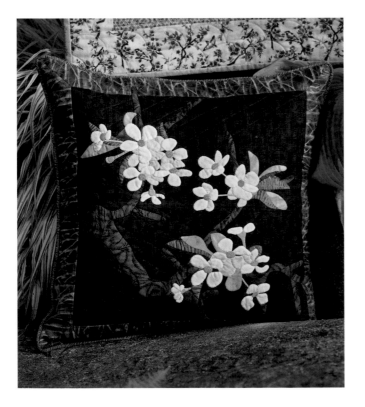

Constructing the Cushion or Wall-Hanging Top

Refer to "The Appliqué Process" on page 17.

1. Use the patterns on pages 64–67 to make a complete pattern. Trace the complete pattern onto plastic or vinyl to make the overlay.

2. Use the pattern to make freezer-paper templates for the appliqués. Refer to the color key on page 63 to make the appliqués from the fabrics indicated.

3. Refer to "Adding Borders" on page 23 to sew the borders to the background, using the butted-corner method for the wall hanging and the mitered-corner method for the cushion. *For the wall hanging,* add the 1¾"-wide inner-border strips to the sides of the background square, and then add the 1½"-wide inner-border strip to the top and the 3"-wide inner-border strip to the bottom. Join the 3½" x 17½" outer-border strips to the sides and then the 3½" x 23½" outer-border strips to the top and bottom.

4. Refer to "Making Bias Strips and Stems" on page 21 to make stem pieces 22, 55, 56, 88, and 105. Cut the strips 1" wide for ⅛"-wide finished stems.

5. Appliqué pieces 1–57 to the background, stitching in numerical order.

6. Appliqué the following pieces together to make units: 58 and 59; 60 and 61.

7. Appliqué pieces 58–129 to the background, stitching in numerical order.

8. Remove all the freezer-paper templates.

Finishing

1. Layer the appliquéd top with batting and backing; baste the layers together.

2. Quilt as desired.

3. Refer to "Cushion Finishing" on page 29 or "Wall-Hanging Finishing" on page 32 for the appropriate instructions to finish your quilted piece.

Cherry Blossom Color Keys

Cushion

Fabric color	Piece(s)
Brown	1, 2, 3, 4, 5, 6, 7, 8, 9, 10, 11, 12, 13, 14, 15
Pale stem green	22, 55, 56, 88, 105
Light green	16, 28, 30, 33, 34, 57, 58, 60, 84, 86, 90, 100
Medium green	29, 31, 32, 61, 62, 83, 87, 101
Medium dark green	59, 85
Green speckled	27, 46, 48, 53, 70, 76, 82, 94, 112, 119, 123, 129
Ivory 1	19, 20, 23, 24, 25, 35, 36, 40, 43, 44, 47, 50, 51, 52, 68, 69, 75, 79, 80, 81, 92, 95, 108, 111, 116, 117, 120, 121, 122, 125, 126, 127, 128
Ivory 2	18, 21, 42, 65, 66, 71, 73, 78, 91, 93, 98, 99, 113, 118, 124
Very pale peach	17, 26, 38, 39, 45, 49, 64, 67, 72, 74, 77, 103, 106, 110, 114
Very pale yellow	37, 41, 54, 63, 96, 97, 102, 104, 107, 109, 115
Yellow	89

Wall Hanging

Fabric color	Piece(s)
Brown	1, 2, 3, 4, 5, 6, 7, 8, 9, 10, 11, 12, 13, 14, 15
Pale stem green	22, 55, 56, 88, 105
Light green 1	16, 34, 90, 100
Light green 2	28, 30, 33, 57, 58, 60, 84, 86
Medium green	29, 31, 61, 62, 83, 87, 101
Medium dark green	32, 59, 85
Green speckled	27, 46, 48, 53, 70, 76, 82, 94, 112, 119, 123, 129
Pink 1 (lightest)	19, 20, 23, 24, 25, 35, 36, 40, 43, 44, 47, 50, 51, 52, 68, 69, 75, 79, 80, 81, 92, 95, 108, 111, 116, 117, 120, 121, 122, 125, 126, 127, 128
Pink 2	18, 21, 42, 65, 66, 71, 73, 78, 91, 93, 98, 99, 113, 118, 124
Pink 3	17, 26, 38, 39, 45, 49, 64, 67, 72, 74, 77, 103, 106, 110, 114
Pink 4	37, 41, 54, 63, 96, 97, 102, 104, 107, 109, 115
Pink 5 (darkest)	89

Cherry blossoms in our garden. Photo by Jonathan Propst.

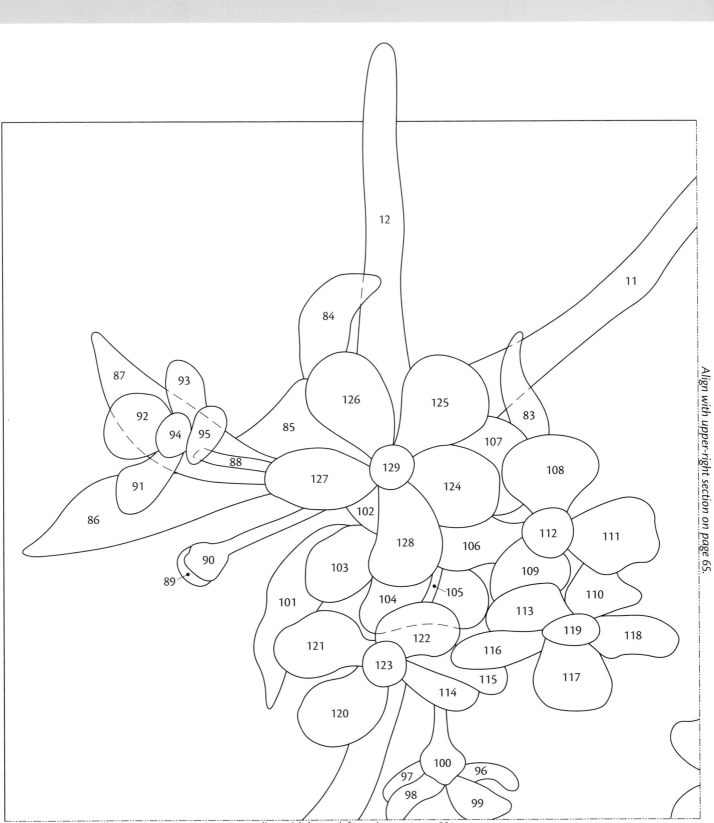

Align with upper-right section on page 65.

Align with lower-left section on page 66.

Cherry Blossom appliqué pattern
Upper-left section

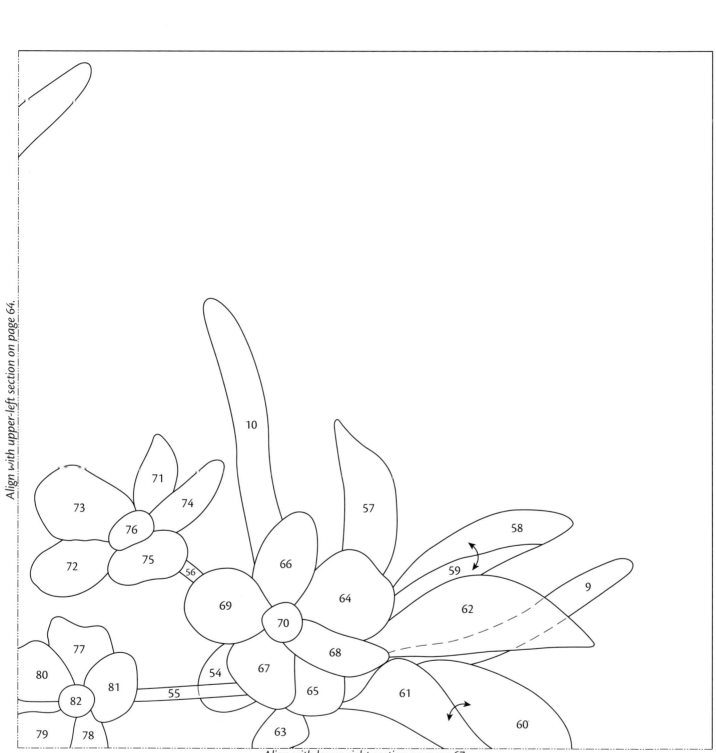

Align with upper-left section on page 64.

Align with lower-right section on page 67.

Cherry Blossom appliqué pattern
Upper-right section

Align with upper-left section on page 64.

Align with lower-right section on page 67.

Cherry Blossom appliqué pattern
Lower-left section

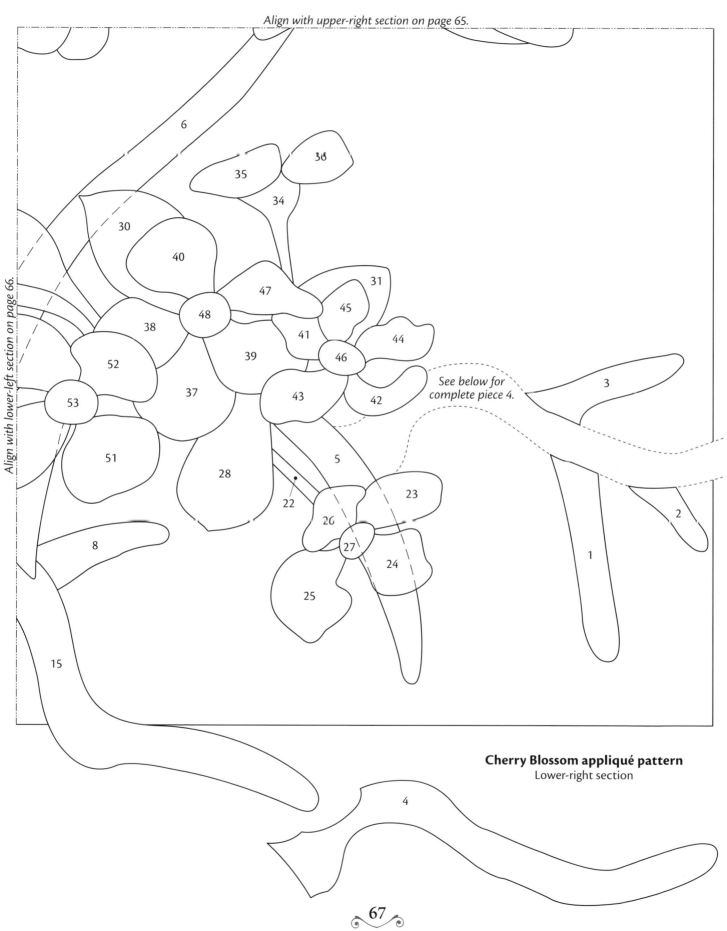

Align with upper-right section on page 65.

Align with lower-left section on page 66.

6

35

36

34

30

40

31

47

45

38

48

41

44

52

39

46

37

53

43

42

See below for
complete piece 4.

3

51

28

5

2

22

23

8

26

27

1

24

25

15

Cherry Blossom appliqué pattern
Lower-right section

4

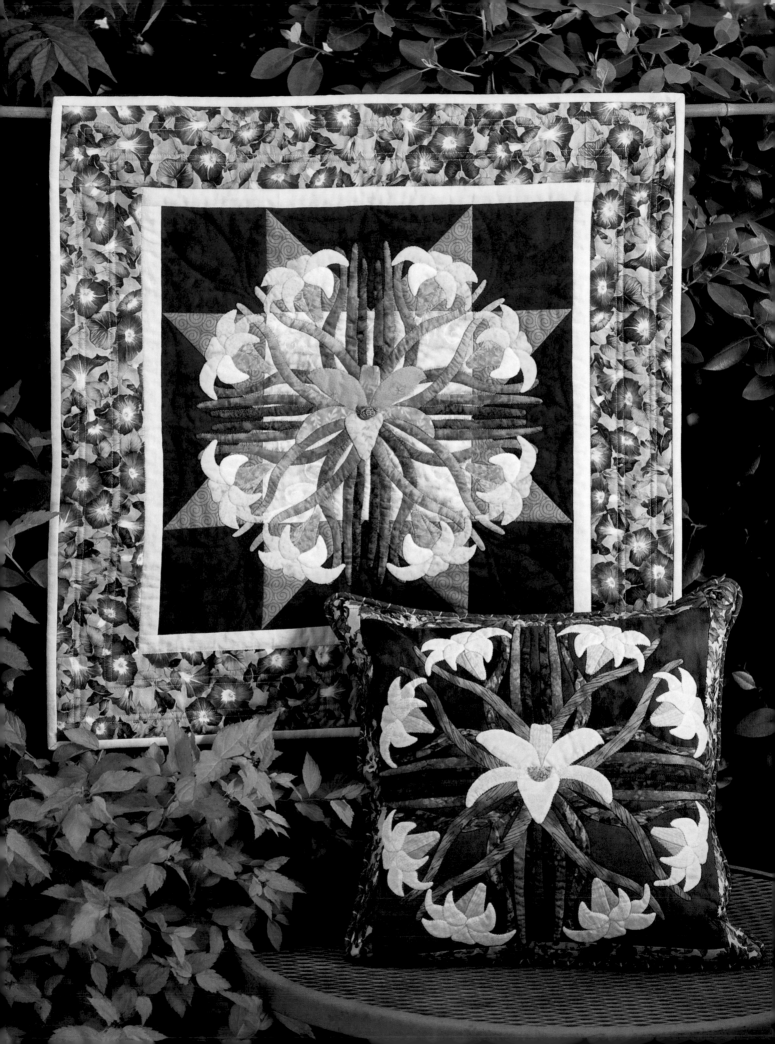

Lily

Cushion finished size: 16" x 16"
Wall-hanging finished size: 24½" x 24½"

In the United States, the lily is the flower traditionally thought to represent Easter. That isn't the case here in England, although lilies are certainly popular in the flower shops and gardens. The fabrics used in this cushion, with its ivory flowers and purple background, make it perfect for Easter decorating but beautiful enough to be considered for year-round display. In fact, lilies bloom in many different hues, so use any color you'd like. If you enjoy embroidery, consider embroidering gold anthers on these lilies. Although this is a symmetrical design, the flowers and leaves are organic, so don't worry if some pieces become less than symmetrical during stitching. It just adds to the charm of the piece!

Materials

Yardages are based on 42"-wide fabric.

Cushion

¼ yard of floral for border

1 fat quarter of purple fabric for background

⅛ yard of fabric for piping

Fat eighths of at least 4 different green fabrics for leaves
 (refer to the color key on page 71 for specifics)

Scraps of 8 different ivory and ecru fabrics for flowers
 (refer to the color key on page 71 for specifics)

Scrap of green fabric for stems

Scrap of rust spotted print for center flower

18½" x 18½" square of fabric for backing

Fabric for cushion back: ⅝ yard for overlapped back or
 1 fat quarter for zippered back

17½" x 17½" square of batting

2 yards of cording

16" zipper to match cushion back (for zippered back only)

Plastic or vinyl for overlay

Freezer paper

Wall Hanging

½ yard of print for outer border

1 fat quarter of pale blue print for background

1 fat quarter of medium blue print for background

1 fat quarter of dark blue fabric for background

⅛ yard of pale blue fabric for inner border

Fat eighths of at least 4 different green fabrics for leaves
 (refer to the color key on page 71 for specifics)

Scraps of at least 8 different yellow and gold fabrics for
 flowers (refer to the color key on page 71 for specifics)

Scraps of at least 3 different orange fabrics for flowers
 (refer to the color key on page 71 for specifics)

Scrap of green fabric for stems

Scrap of rust spotted print for center flower

¼ yard of fabric for binding

26½" x 26½" square of fabric for backing

25½" x 25½" square of batting

Plastic or vinyl for overlay

Freezer paper

Cutting

All measurements include ¼"-wide seam allowances.

Cushion

From the background fabric, cut:
❖ 1 square, 13½" x 13½"

From the border fabric, cut:
❖ 2 strips, 2" x 13½"
❖ 2 strips, 2" x 16½"

Wall Hanging

From the dark blue fabric, cut:
❖ 1 square, 9¼" x 9¼"; cut twice diagonally to yield 4 quarter-square triangles
❖ 4 squares, 4½" x 4½"

From the medium blue print, cut:
❖ 4 squares, 4⅞" x 4⅞"; cut each square once diagonally to yield 2 half-square triangles (8 total)

From the pale blue print, cut:
❖ 1 square, 8½" x 8½"

From the inner-border fabric, cut:
❖ 2 strips, 1¼" x 16½"
❖ 2 strips, 1¼" x 18"

From the outer-border fabric, cut:
❖ 2 strips, 3¾" x 18"
❖ 2 strips, 3¾" x 24½"

From the binding fabric, cut:
❖ 3 strips, 2¼" x 42"

Constructing the Cushion Top

Refer to "The Appliqué Process" on page 17.

1. Refer to "Adding Borders" on page 23 to stitch the border strips to the background, using the butted-corner method.

2. Use the patterns on pages 72–75 to make a complete pattern. Trace the complete pattern onto plastic or vinyl to make the overlay.

3. Refer to the pattern, the color key on page 71, and "Making Bias Strips and Stems" on page 21 to make

stem pieces 1–8. Cut the strips 1¼" wide for ¼"-wide finished stems.

4. Use the pattern to make freezer-paper templates for the appliqués. Refer to the color key on page 71 to make the appliqués from the fabrics indicated.

5. Appliqué the following pieces together to make units: 41 and 42; 49 and 50; 57 and 58; 65 and 66; 73 and 74; 81 and 82; 89 and 90; 97 and 98.

6. Appliqué pieces 1–111 to the background, stitching in numerical order.

7. Remove all the freezer-paper templates.

Constructing the Wall-Hanging Top

Refer to "The Appliqué Process" on page 17.

1. Stitch the long side of a medium blue triangle to one short side of a dark blue triangle. Press the seam allowance toward the medium blue. Repeat on the other short side of the dark blue triangle to form a flying-geese unit. Press. Repeat to make a total of four units.

Make 4.

2. Arrange the four flying-geese units from step 1, the four dark blue squares, and the pale blue 8½" square into three rows. Sew the pieces in each row together. Press the seam allowances away from the flying-geese units. Sew the rows together, matching seams. Press the seam allowances toward the middle row.

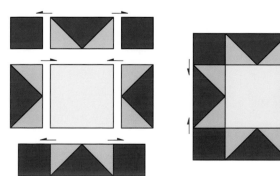

3. Use the patterns on pages 72–75 to make a complete pattern. Trace the complete pattern onto plastic or vinyl to make the overlay.

4. Refer to the pattern, the color key below, and "Making Bias Strips and Stems" on page 21 to make stem pieces 1–8. Cut the strips 1¼" wide for ¼"-wide finished stems.

5. Use the pattern to make freezer-paper templates for the appliqués. Refer to the color key below to make the appliqués from the fabrics indicated.

6. Appliqué the following pieces together to make units: 41 and 42; 49 and 50; 57 and 58; 65 and 66; 73 and 74; 81 and 82; 89 and 90; 97 and 98.

7. Appliqué pieces 1–111 to the background, stitching in numerical order.

8. Refer to "Adding Borders" on page 23 to stitch the border strips to the background, using the butted-corner method. Add the 1¼"-wide inner-border strips and then the 3¾"-wide outer-border strips.

9. Remove all the freezer-paper templates.

Finishing

1. Layer the appliquéd top with batting and backing; baste the layers together.

2. Quilt as desired.

3. Refer to "Cushion Finishing" on page 29 or "Wall-Hanging Finishing" on page 32 for the appropriate instructions to finish your quilted piece.

Lily Color Keys

Cushion

Fabric color	Piece(s)
Dark ecru	41, 49, 57, 65, 73, 81, 89, 97
Ecru	42, 50, 58, 66, 74, 82, 90, 98, 105
Dark ivory	44, 52, 60, 68, 76, 84, 92, 100, 106, 107
Medium dark ivory	43, 51, 59, 67, 75, 83, 91, 99
Ivory 1	45, 54, 62, 70, 78, 86, 93, 102
Ivory 2	46, 53, 61, 69, 77, 85, 94, 101, 110
Pale ivory	47, 55, 63, 71, 79, 87, 95, 103
Very pale ivory	48, 56, 64, 72, 80, 88, 96, 104, 108, 109
Light green	27, 28, 31, 32, 35, 36, 39, 40
Medium green	25, 26, 29, 30, 33, 34, 37, 38
Medium dark green	11, 12, 15, 16, 19, 20, 23, 24
Dark green	9, 10, 13, 14, 17, 18, 21, 22
Stem green	1, 2, 3, 4, 5, 6, 7, 8
Rust spotted	111

Wall Hanging

Fabric color	Piece(s)
Gold 1	41, 49, 57, 65, 73, 81, 89, 97
Gold 2	42, 50, 58, 66, 74, 82, 90, 98
Medium yellow 1	44, 52, 60, 68, 76, 84, 92, 100
Medium yellow 2	43, 51, 59, 67, 75, 83, 91, 99, 110
Yellow 1	45, 54, 62, 70, 78, 86, 93, 102
Yellow 2	46, 53, 61, 69, 77, 85, 94, 101, 110
Light yellow	47, 55, 63, 71, 79, 87, 95, 103
Pale yellow	48, 56, 64, 72, 80, 88, 96, 104
Orange 1	106, 107
Orange 2	108, 109
Orange 3	105
Light green	27, 28, 31, 32, 35, 36, 39, 40
Medium green	25, 26, 29, 30, 33, 34, 37, 38
Medium dark green	11, 12, 15, 16, 19, 20, 23, 24
Dark green	9, 10, 13, 14, 17, 18, 21, 22
Stem green	1, 2, 3, 4, 5, 6, 7, 8
Rust spotted	111

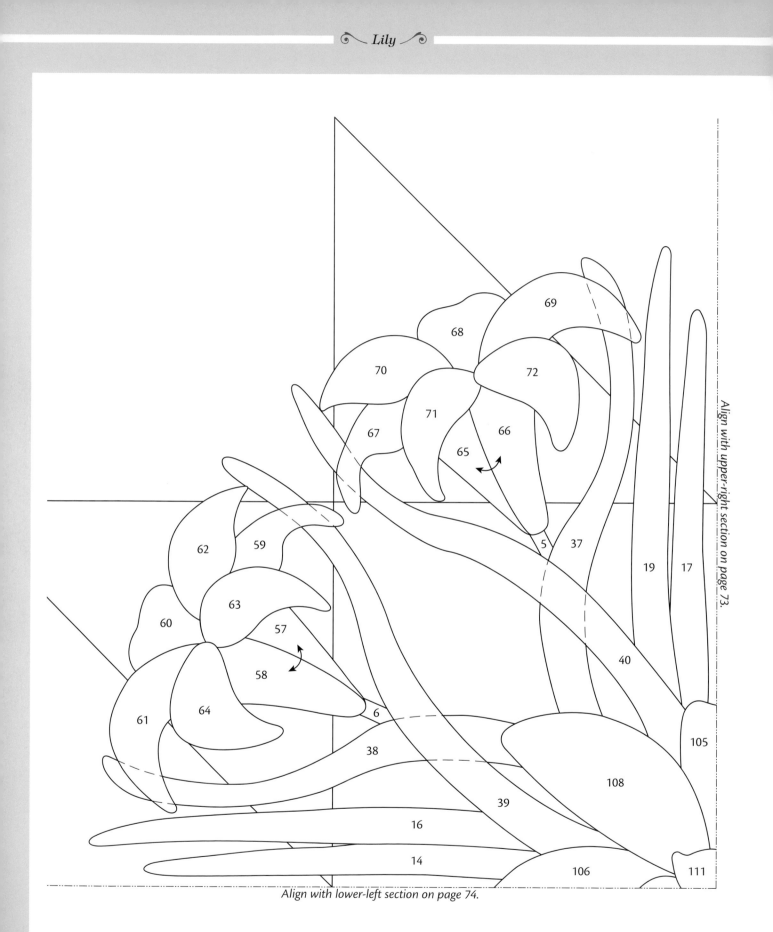

Align with upper-right section on page 73.

Align with lower-left section on page 74.

Lily appliqué pattern
Upper-left section

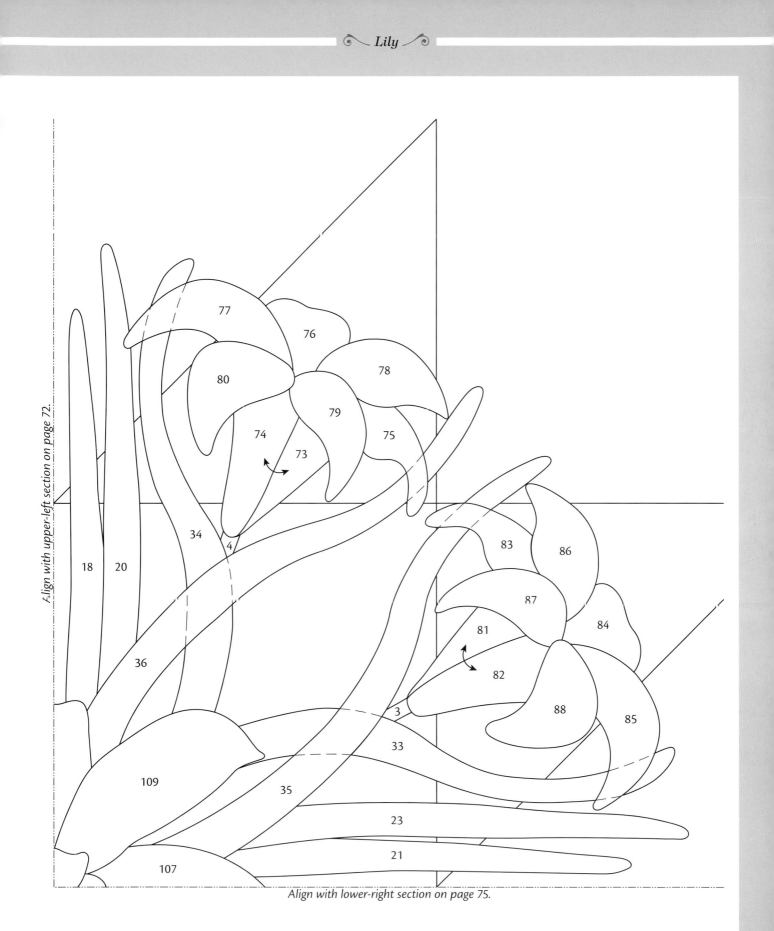

Align with lower-right section on page 75.

Lily appliqué pattern
Upper-right section

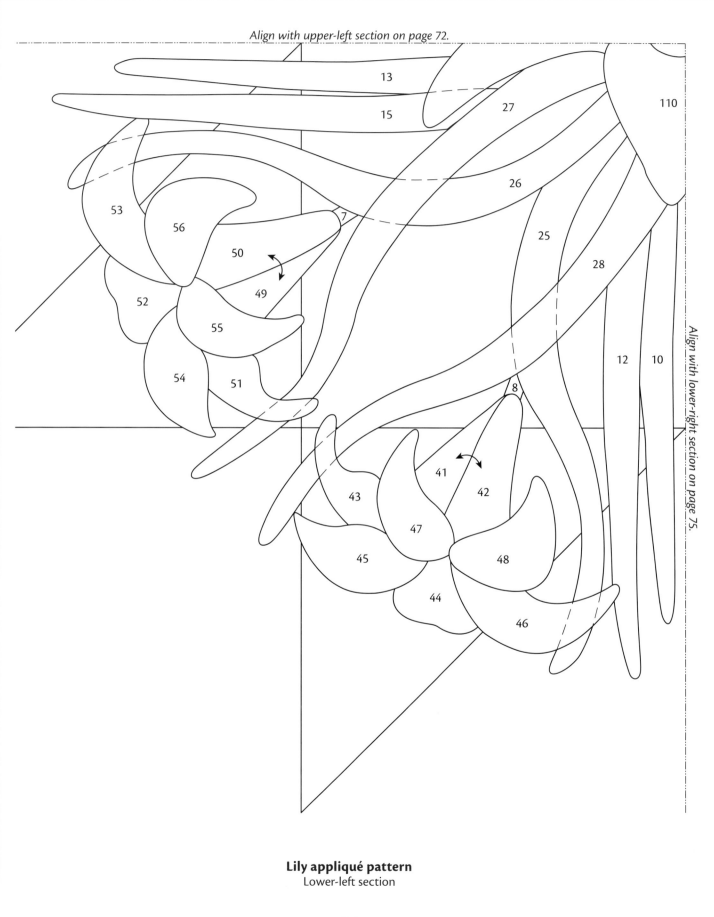

Align with upper-left section on page 72.

13

15

27

110

53

56

7

26

25

28

50

49

52

55

12

10

54

51

8

Align with lower-right section on page 75.

41

42

43

47

45

48

44

46

Lily appliqué pattern
Lower-left section

Align with upper-right section on page 73.

Align with lower-left section on page 74.

22

24

30

29

31

32

2

9 11

1

96

94

90

89

95

92

91 93

97

98

99

103

104

102

100

101

Lily appliqué pattern
Lower-right section

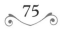

Tulip

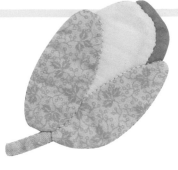

Cushion finished size: 16" x 16"
Wall-hanging finished size: 21½" x 21½"

Tulips are probably most strongly associated with the Netherlands. However, my inspiration for this wall hanging was actually the black tulips planted at a stately home near Leeds. The black tulips are, in fact, a really beautiful deep purple, and I've tried to capture these in fabric. The Pinwheel blocks in the wall hanging give a feel of Dutch windmills overlooking the tulip fields.

Materials

Yardages are based on 42"-wide fabric.

Cushion

¼ yard of floral for border

1 fat quarter of yellowish green fabric for background

⅛ yard of fabric for piping

Scraps of at least 6 different green fabrics for leaves and stems (refer to the color key on page 81 for specifics)

Scraps of at least 3 different yellow fabrics for flowers (refer to the color key on page 81 for specifics)

18½" x 18½" square of fabric for backing

Fabric for cushion back: ⅝ yard for overlapped back or 1 fat quarter for zippered back

17½" x 17½" square of batting

2 yards of cording

16" zipper to match cushion back (for zippered back only)

Plastic or vinyl for overlay

Freezer paper

Wall Hanging

½ yard of floral for pieced border

¼ yard of pale gold fabric for pieced border

1 fat quarter of light gold fabric for background

1 fat quarter of medium-light gold fabric for background

⅛ yard of purple print for inner border

Scraps of at least 6 different green fabrics for leaves and stems (refer to the color key on page 81 for specifics)

Scraps of at least 3 different purple fabrics for flowers (refer to the color key on page 81 for specifics)

¼ yard of fabric for binding

23½" x 23½" rectangle of fabric for backing

22½" x 22½" rectangle of batting

Plastic or vinyl for overlay

Freezer paper

Cutting

All measurements include ¼"-wide seam allowances.

Cushion

From the background fabric, cut:
- 1 square, 13" x 13"

From the border fabric, cut:
- 2 strips, 2½" x 12½"
- 2 strips, 2½" x 16½"

Wall Hanging

From the light gold fabric, cut:
- 2 squares, 8" x 8"

From the medium-light gold fabric, cut:
- 2 squares, 8" x 8"

From the inner-border fabric, cut:
- 2 strips, 1¼" x 14"
- 2 strips, 1¼" x 15½"

From the floral border fabric, cut:
- 12 squares, 3½" x 3½"
- 24 squares, 2⅜" x 2⅜"

From the pale gold border fabric, cut:
- 24 squares, 2⅜" x 2⅜"

From the binding fabric, cut:
- 3 strips, 2¼" x 42"

Constructing the Cushion Top

Refer to "The Appliqué Process" on page 17.

1. Use the patterns on pages 82–85 to make a complete pattern. Trace the complete pattern onto plastic or vinyl to make the overlay.

2. Use the pattern to make freezer-paper templates for the appliqués. Refer to the color key on page 81 to make the appliqués from the fabrics indicated.

3. Appliqué the following pieces together to make units: 5 and 6; 9 and 10; 11 and 12; 15 and 16; 17 and 18; 21 and 22; 23 and 24; 27 and 28.

4. Turn under and baste the seam allowance on each side of the base of piece 27. Tack the lower edge in place where unit 5/6 will cover it.

5. Appliqué pieces 1–44 to the background, stitching in numerical order. Remove the basting from piece 27.

6. Trim the appliquéd square so that it measures 12½" x 12½".

7. Refer to "Adding Borders" on page 23 to stitch the border strips to the background, using the butted-corner method.

8. Remove all the freezer-paper templates.

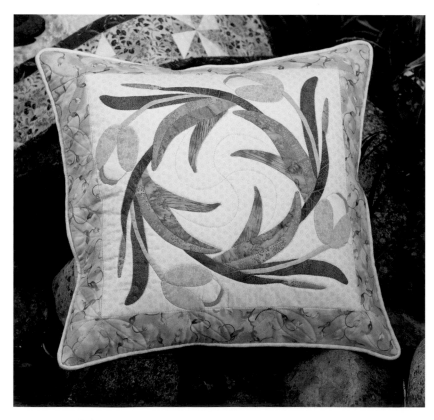

Constructing the Wall-Hanging Top

Refer to "The Appliqué Process" on page 17.

1. Place a light gold 8" square on top of each medium-light gold 8" square, right sides together. Using a pencil and ruler, draw a diagonal line from corner to corner on the wrong side of the light gold squares. Stitch a scant ¼" from both sides of the drawn line. Cut the squares apart on the drawn line and press the seam allowances toward the medium-light gold triangles. Each pair of squares will yield two half-square-triangle units.

2. Arrange the half-square-triangle units into two rows of two units each. Sew the units in each row together, pressing the seam allowances in opposite directions. Sew the rows together to complete the Large Pinwheel block. Press the seam allowances in either direction.

3. Use the patterns on pages 82–85 to make a complete pattern. Trace the complete pattern onto plastic or vinyl to make the overlay.

4. Use the pattern to make freezer-paper templates for the appliqués. Refer to the color key on page 81 to make the appliqués from the fabrics indicated.

5. Appliqué the following pieces together to make units: 5 and 6; 9 and 10; 11 and 12; 15 and 16; 17 and 18; 21 and 22; 23 and 24; 27 and 28.

6. Turn under and baste the seam allowance on each side of the base of piece 27. Tack the lower edge in place where unit 5/6 will cover it.

7. Appliqué pieces 1–44 to the Large Pinwheel block background, stitching in numerical order. Remove the basting from piece 27.

8. Trim the appliqué square so that it measures 14" x 14", with the center 7" away from all the edges.

9. Refer to "Adding Borders" on page 23 to stitch the 1¼" inner-border strips to the background, using the butted-corner method.

10. Refer to step 1 to make half-square-triangle units for the border, using the floral and pale gold 2⅜" squares. Make a total of 48 units. Each unit should measure 2" square.

11. Refer to step 2 to sew four units into a Small Pinwheel block. Repeat to make a total of 12 blocks.

12. Arrange the Small Pinwheel blocks and floral 3½" squares as shown to make the border units.

Top/bottom border.
Make 2.

Side border.
Make 2.

13. Stitch the top and bottom border units to the top and bottom edges of the quilt top. Press the seam allowances toward the inner border. Join the side border units to the sides of the quilt top. Press the seam allowances toward the inner border.

14. Remove all the freezer-paper templates.

Finishing

1. Layer the appliquéd top with batting and backing; baste the layers together.

2. Quilt as desired.

3. Refer to "Cushion Finishing" on page 29 or "Wall-Hanging Finishing" on page 32 for the appropriate instructions to finish your quilted piece.

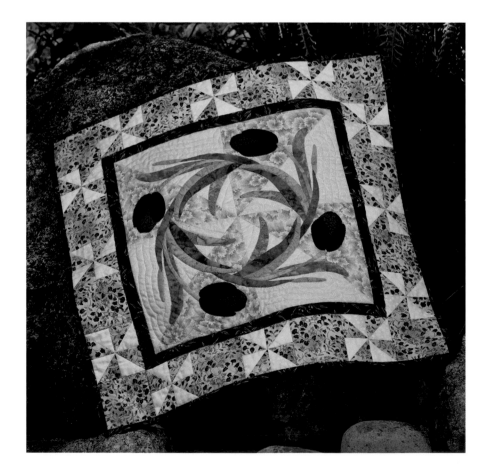

Tulip Color Keys

Cushion

Fabric color	Pieces
Stem green	8, 14, 20, 26
Green 1	1, 2, 3, 4
Green 2	5, 10, 11, 16, 17, 22, 23, 28
Green 3	6, 12, 18, 24
Green 4	7, 13, 19, 25
Green 5	9, 15, 21, 27
Yellowish orange	29, 33, 37, 41
Light yellowish orange	31, 32, 35, 36, 39, 40, 43, 44
Yellow	30, 34, 38, 42

Wall Hanging

Fabric color	Pieces
Stem green	8, 14, 20, 26
Green 1	1, 2, 3, 4
Green 2	5, 10, 11, 16, 17, 22, 23, 28
Green 3	6, 12, 18, 24
Green 4	7, 13, 19, 25
Green 5	9, 15, 21, 27
Very dark purple	29, 33, 37, 41
Dark purple	31, 32, 35, 36, 39, 40, 43, 44
Medium-dark purple	30, 34, 38, 42

Black tulips at Harewood House, near Leeds, England. Photo by Jonathan Propst.

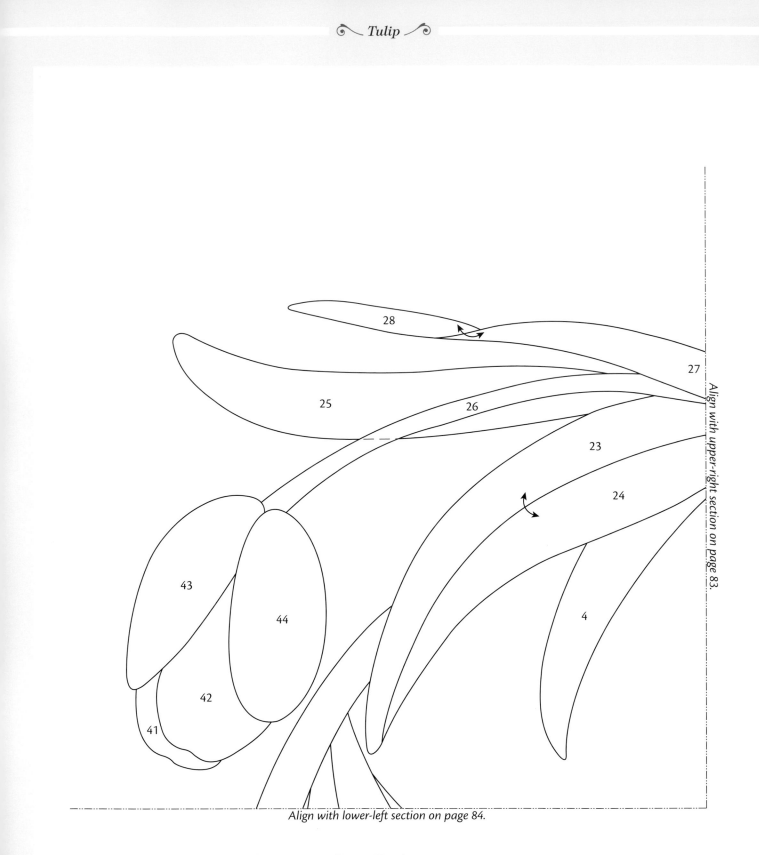

Align with upper-right section on page 83.

Align with lower-left section on page 84.

Tulip appliqué pattern
Upper-left section

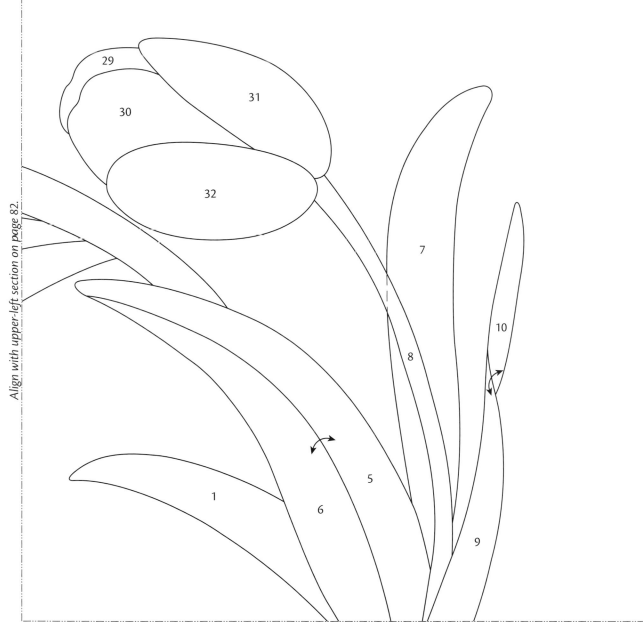

Align with upper-left section on page 82.

Align with lower-right section on page 85.

Tulip appliqué pattern
Upper-right section

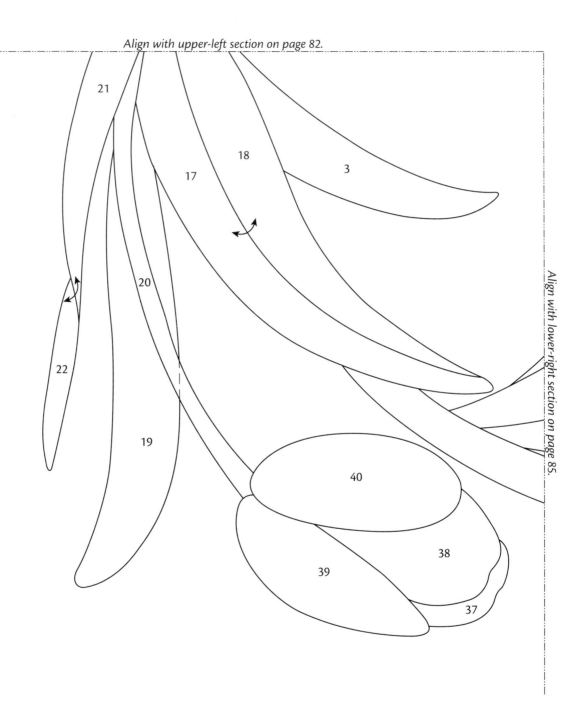

Align with upper-left section on page 82.

21

18

17

3

20

22

19

Align with lower-right section on page 85.

40

38

39

37

Tulip appliqué pattern
Lower-left section

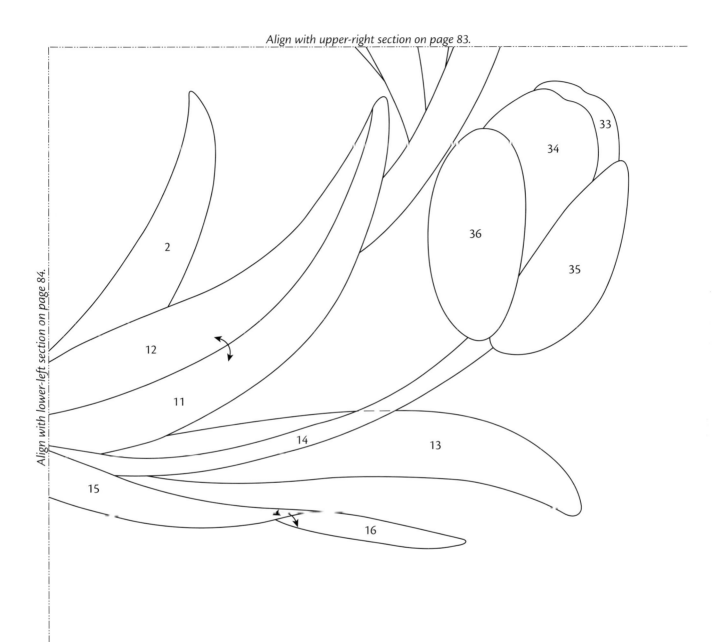

Tulip appliqué pattern
Lower-right section

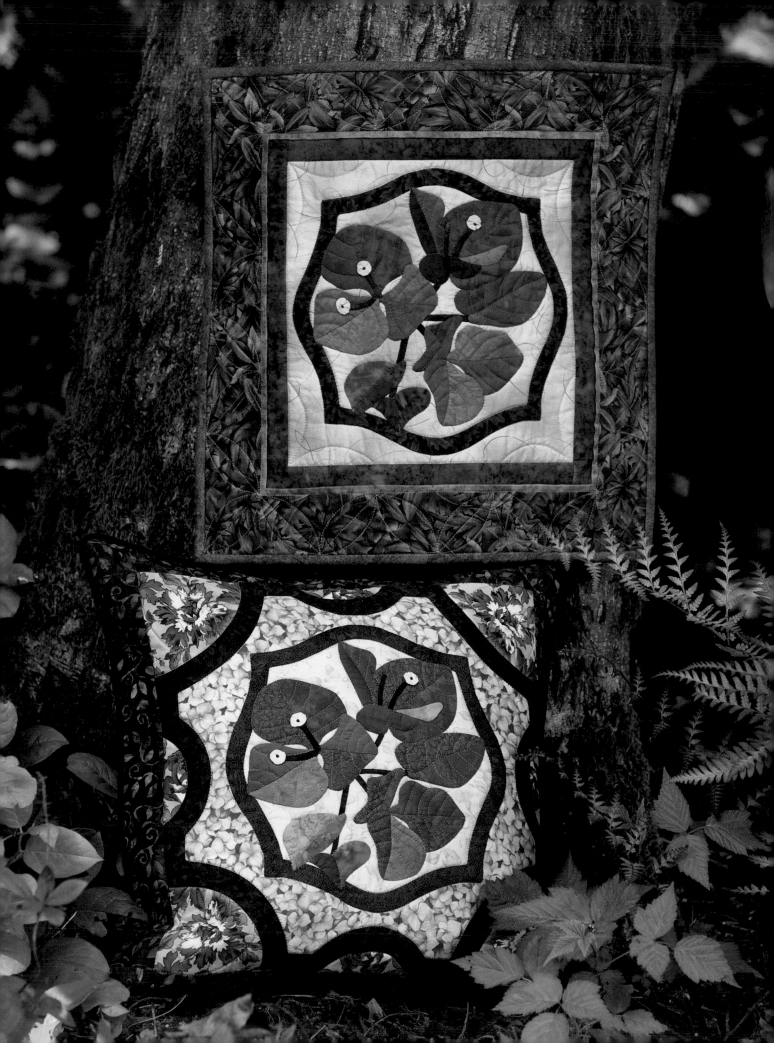

Bougainvillea

Cushion finished size: 17" x 17"

Wall-hanging finished size: 16½" x 16½"

This is a flower that I was not familiar with until I traveled to southern Portugal, where it grows everywhere. What is interesting about the bougainvillea is that, like the poinsettia, the plant gets most of its colorful appearance not from the flowers, but from bracts (special colorful leaves). The bougainvillea flower is small and white, and in this project I have included instructions for making a dimensional flower using a yo-yo.

Materials

Yardages are based on 42"-wide fabric.

Cushion

⅓ yard of purple batik for border

1 fat quarter of pale fabric for background

1 fat quarter of light green print for background

1 fat quarter of floral for background

1 fat quarter of dark purple fabric for outer ring

1 fat quarter of medium purple fabric for inner ring

⅛ yard of fabric for piping

Scraps of at least 3 different green fabrics for leaves (refer to the color key on page 90 for specifics)

Scraps of at least 6 different pink fabrics for flowers (refer to the color key on page 90 for specifics)

Scrap of dark brown fabric for stems

Scrap of rust fabric for stamen

Scrap of white or ivory fabric for flowers

19½" x 19½" square of fabric for backing

⅝ yard of fabric for zippered or overlapped back

18½" x 18½" square of batting

2 yards of cording

18" zipper to match cushion back (for zippered back only)

Plastic or vinyl for overlay

Freezer paper

Dark brown embroidery floss and embroidery needle (optional)

Wall Hanging

¼ yard of print for outer border

1 fat quarter of pale fabric for background

1 fat quarter of medium-dark green fabric for ring

⅛ yard of medium green fabric for inner border

⅛ yard of medium-light green fabric for border accent

Scraps of at least 3 different green fabrics for leaves (refer to the color key on page 90 for specifics)

Scraps of at least 6 different purple fabrics for flowers (refer to the color key on page 90 for specifics)

Scrap of dark brown fabric for stems

Scrap of rust fabric for stamen

Scrap of white or ivory fabric for flowers

¼ yard of fabric for binding

18½" x 18½" rectangle of fabric for backing

17½" x 17½" rectangle of batting

Plastic or vinyl for overlay

Freezer paper

Dark brown embroidery floss and embroidery needle (optional)

Cutting

All measurements include ¼"-wide seam allowances.

Cushion
From the pale background fabric, cut:
❖ 1 square, 10" x 10"

From the light green background fabric, cut:
❖ 1 square, 13" x 13"

From the floral, cut:
❖ 1 square, 15" x 15"

From the border fabric, cut:
❖ 2 strips, 2" x 14½"
❖ 2 strips, 2" x 17½"

Wall Hanging
From the pale background fabric, cut:
❖ 1 square, 10½" x 10½"

From the inner-border fabric, cut:
❖ 2 strips, 1½" x 10½"
❖ 2 strips, 1½" x 12½"

From the border accent fabric, cut:
❖ 4 strips, 1" x 12½"

From the outer-border fabric, cut:
❖ 2 strips, 2½" x 12½"
❖ 2 strips, 2½" x 16½"

From the binding fabric, cut:
❖ 2 strips, 2¼" x 42"

Constructing the Cushion Top

Refer to "The Appliqué Process" on page 17.

1. Use the patterns on pages 92–95 to make a complete pattern. Trace the complete pattern onto plastic or vinyl to make the overlay.

2. Use the pattern to make freezer-paper templates for the appliqués. Refer to the color key on page 90 to make the appliqués from the fabrics indicated.

3. Appliqué the following pieces together to make units: 6 and 7; 8 and 9; 10 and 11; 12 and 13; 14 and 15; 16 and 17; 18 and 19; 20 and 21; 24 and 25; 26 and 27; 28 and 29; 30 and 31.

4. Appliqué the inside edge of piece 1 (inner ring) to the pale background square. Trim the excess background fabric from behind piece 1, leaving a ¼" seam allowance.

5. Center the piece 1 unit onto the pale green background square and appliqué around the outside edge of piece 1.

6. Appliqué pieces 2–33 to the background, stitching in numerical order. Also stitch pieces 34–36 if you don't want to add the dimensional yo-yos.

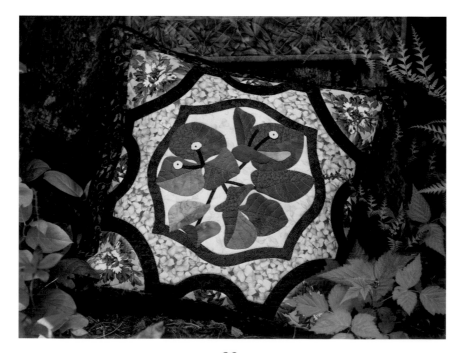

7. Center piece 37 (outer ring) onto the background square and appliqué the inside edge. Trim the excess pale green fabric from behind piece 37, leaving a ¼" seam allowance.

8. Center the background unit onto the floral square and appliqué the outer edge of piece 37. Trim the excess floral fabric from behind piece 37, leaving a ¼" seam allowance. Trim the completed background square to 14½".

9. Refer to "Adding Borders" on page 23 to stitch the border strips to the background, using the butted-corner method.

10. Remove all the freezer-paper templates.

Constructing the Wall-Hanging Top

Refer to "The Appliqué Process" on page 17.

1. Use the patterns on pages 92–95 to make a complete pattern. Trace the complete pattern onto plastic or vinyl to make the overlay.

2. Use the pattern to make freezer-paper templates for the appliqués. Refer to the color key on page 90 to make the appliqués from the fabrics indicated.

3. Appliqué the following pieces together to make units: 6 and 7; 8 and 9; 10 and 11; 12 and 13; 14 and 15; 16 and 17; 18 and 19; 20 and 21; 24 and 25; 26 and 27; 28 and 29; 30 and 31.

4. Appliqué pieces 1–33 to the background, stitching in numerical order. Also stitch pieces 34–36 if you don't want to add the dimensional puffs.

5. Refer to "Adding Borders" on page 23 to stitch the 1½"-wide inner-border strips to the background square, using the butted-corner method. Stitch the top and bottom first and then the sides.

6. Press each 1"-wide border accent strip in half lengthwise, wrong sides together. With the raw edges aligned, stitch strips to the top and bottom edges of the wall hanging. Stitch the remaining two strips to the sides.

7. Using the butted-corner method, add the 2½"-wide outer-border strips to the wall hanging.

8. Remove all the freezer-paper templates.

Finishing

1. Layer the appliquéd top with batting and backing; baste the layers together.

2. Quilt as desired.

3. Refer to "Cushion Finishing" on page 29 or "Wall-Hanging Finishing" on page 32 for the appropriate instructions to finish your quilted piece.

4. If you are using the optional yo-yos, cut three 1" circles from white or ivory fabric. Run a basting stitch approximately ⅛" in from the edge of each circle, leaving long thread tails at the beginning and end.

5. Gather each circle to create a small yo-yo. Tie the thread tails in a knot to secure the shape. Tuck the raw edges inside. Pinch the yo-yo and make a few tacking stitches through the center.

Tacking stitches

6. Make a French knot in the center of each yo-yo. Using six strands of dark brown embroidery thread and your embroidery needle, knot one end of the strands and bring them up through the inside of the yo-yo. Wrap the thread once around the needle. Push the needle back into the yo-yo, making sure the knot stays close to the fabric. Knot off the thread on the wrong side of the yo-yo.

7. With the opening side down, position a yo-yo in place of piece 34. Tack it in place on the underside of the yo-yo, hiding the thread. Knot off the thread, hiding it under the yo-yo. Repeat with the remaining two yo-yos for pieces 35 and 36.

Bougainvillea Color Keys

Cushion

Fabric color	Piece(s)
Pink 1 (lightest)	14, 25, 31
Pink 2	11, 29, 30
Pink 3	10, 15, 16, 18, 28
Pink 4	12, 20, 26
Pink 5	13, 17, 21, 27
Pink 6 (darkest)	19, 24
Green 1 (lightest)	8
Green 2	6, 9
Green 3 (darkest)	7
Dark brown	2, 3, 4, 5
Purple	1
Dark purple	37
Rust	22, 23, 32, 33
White or ivory	34, 35, 36

Wall Hanging

Fabric color	Piece(s)
Purple 1 (lightest)	14, 25, 31
Purple 2	11, 29, 30
Purple 3	10, 15, 16, 18, 28
Purple 4	12, 20, 26
Purple 5	13, 17, 21, 27
Purple 6 (darkest)	19, 24
Green 1 (lightest)	8
Green 2	6, 9
Green 3 (darkest)	7
Dark brown	2, 3, 4, 5
Medium-dark green	1
Rust	22, 23, 32, 33
White or ivory	34, 35, 36

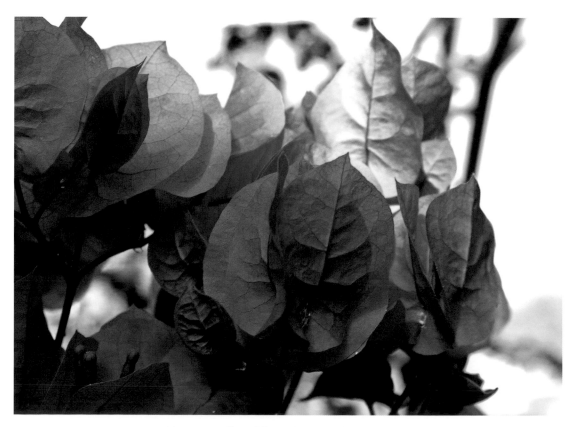

Bougainvillea. Photo by Jonathan Propst.

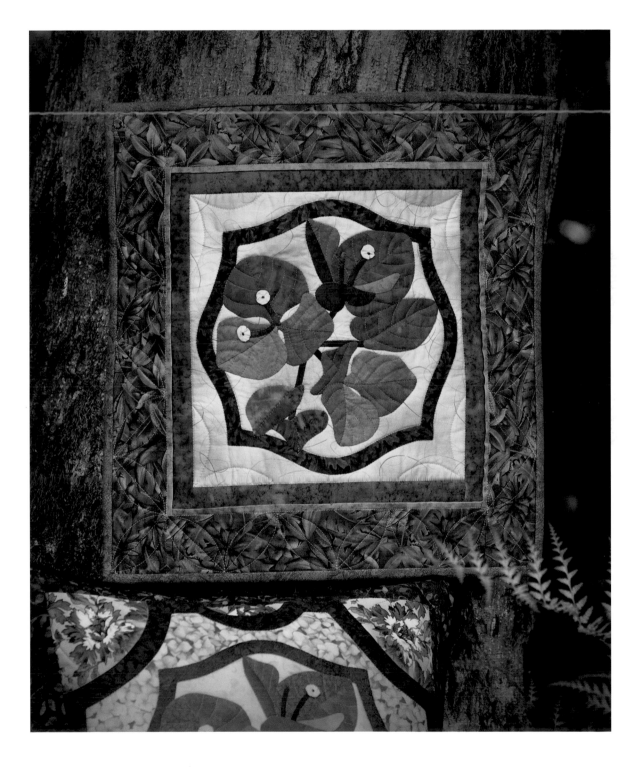

37

Cushion border appliqué

1

18

19

Align with upper-right section on page 93.

26

27

35

33

29

34

32

Align with lower-left section on page 94.

Bougainvillea appliqué pattern
Upper-left section

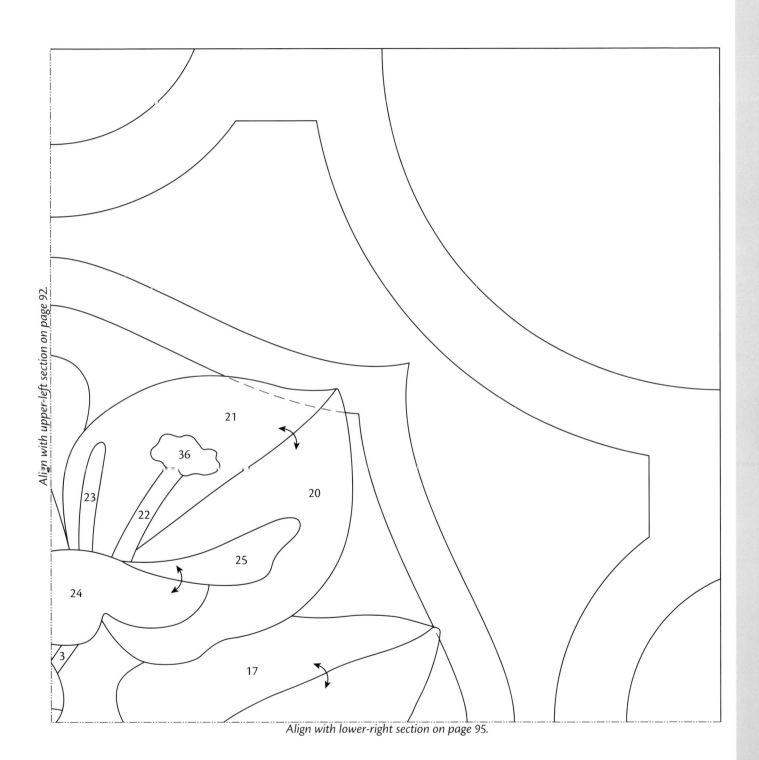

Align with upper-left section on page 92.

Align with lower-right section on page 95.

Bougainvillea appliqué pattern
Upper-right section

Align with upper-left section on page 92.

Align with lower-right section on page 95.

Bougainvillea appliqué pattern
Lower-left section

Bougainvillea appliqué pattern
Lower-right section

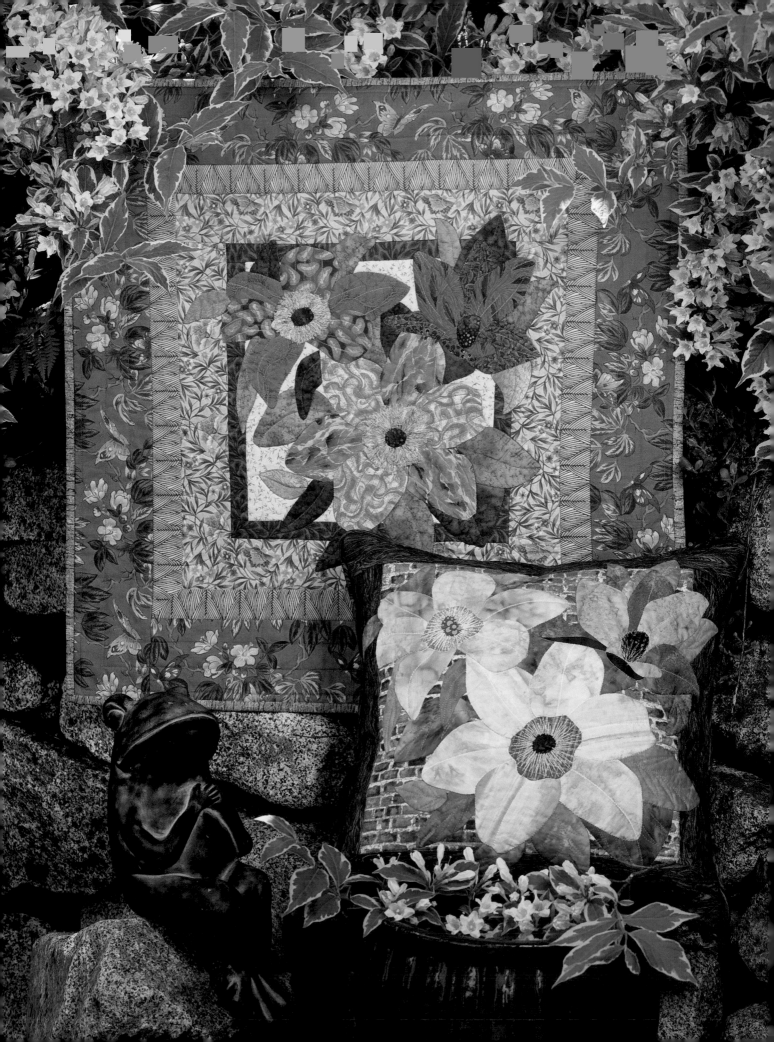

Clematis

Cushion finished size: 16" x 16"
Wall-hanging finished size: 25½" x 25½"

There are many varieties and colors of clematis flowers, and the petals are wide, so this is a good project for using wild fabrics. The stamens on the clematis are particularly noticeable. Try representing them through the optional fringe method that I used on this wall hanging, or simply add machine stitching in the center of the flowers as I did on the cushion.

Materials

Yardages are based on 42"-wide fabric.

Cushion

⅓ yard of wood print for border and piping

1 fat quarter of brick print for background

Scraps of at least 3 different green fabrics for leaves (refer to the color key on page 99 for specifics)

Scraps of at least 7 different purple fabrics for flowers (refer to the color key on page 99 for specifics)

Scraps of 2 different plaids for flower centers

Scraps of 3 different speckled prints for flower centers

18½" x 18½" square of fabric for backing

Fabric for cushion back: ⅝ yard for overlapped back or 1 fat quarter for zippered back

17½" x 17½" square of batting

2 yards of cording

16" zipper to match cushion back (for zippered back only)

Plastic or vinyl for overlay

Freezer paper

Wall Hanging

⅜ yard of dark floral for fourth border

¼ yard of light floral for second border

¼ yard of medium green print for third border and stamen fringe

1 fat quarter of pale print for background

⅛ yard of dark green fabric for first border

Scraps of at least 3 different green fabrics for leaves (refer to the color key on page 99 for specifics)

Scraps of at least 7 different salmon fabrics for flowers (refer to the color key on page 99 for specifics)

Scraps of 2 different green speckled prints for flower centers

¼ yard of fabric for binding

27½" x 27½" square of fabric for backing

26½" x 26½" square of batting

Plastic or vinyl for overlay

Freezer paper

Cutting

All measurements include ¼"-wide seam allowances.

Cushion
From the brick print background fabric, cut:
- 1 square, 12½" x 12½"

From the border fabric, cut:
- 2 strips, 2½" x 12½"
- 2 strips, 2½" x 16½"

Wall Hanging
From the pale print background fabric, cut:
- 1 square, 11" x 11"

From the first-border fabric, cut:
- 2 strips, 1¼" x 11"
- 2 strips, 1¼" x 12½"

From the second-border fabric, cut:
- 2 strips, 2½" x 12½"
- 2 strips, 2½" x 16½"

From the third-border and stamen fabric, cut:
- 4 strips, 1¾" x 19¾"
- 1 strip, 1⅜" x 9"
- 1 strip, 1⅛" x 9"

From the fourth-border fabric, cut:
- 2 strips, 3¾" x 19"
- 2 strips, 3¾" x 25½"

Constructing the Cushion Top

Refer to "The Appliqué Process" on page 17.

1. Refer to "Adding Borders" on page 23 to stitch the border strips to the background square, using the butted-corner method.

2. Use the patterns on pages 100–103 to make a complete pattern. Trace the complete pattern onto plastic or vinyl to make the overlay.

3. Use the pattern to make freezer-paper templates for the appliqués. Refer to the color key on page 99 to make the appliqués from the fabrics indicated.

4. Appliqué the following pieces together to make units: 38 and 39; 42 and 43.

5. Appliqué pieces 1–44 to the background, stitching in numerical order.

6. Remove all the freezer-paper templates.

Constructing the Wall-Hanging Top

Refer to "The Appliqué Process" on page 17.

1. Refer to "Adding Borders" on page 23 to stitch the first and second borders to the background square using the butted-corner method. Add the 1¼"-wide first-border strips first, followed by the 2½"-wide second border strips.

2. Use the patterns on pages 100–103 to make a complete pattern. Trace the complete pattern onto plastic or vinyl to make the overlay.

3. Use the pattern to make freezer-paper templates for the appliqués. Refer to the color key on page 99 to make the appliqués from the fabrics indicated.

4. Appliqué the following pieces together to make units: 38 and 39; 42 and 43.

5. Appliqué pieces 1–32, 34, and 36–44 to the background, stitching in numerical order.

6. Run a basting stitch about ³⁄₁₆" away from one long edge of each of the two 9"-long strips of stamen fabric. Knot one end of the stitching and leave a thread tail on the other end.

7. Using a pin, separate a strand of thread from the unstitched long side on each strip. Continue removing threads until you are about ⅛" from the basting stitches.

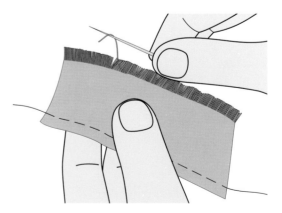

8. Pull the thread tails to gather the strip and form it into a flat circle.

9. Pin the fringe circles in place over the flower-center pieces. Center the 1⅜" fringe circle over piece 34 and the 1⅛" fringe circle over piece 32. Appliqué pieces 33 and 35, stitching through the fringe circles and making sure that the basted edges are tucked inside.

10. Refer to "Adding Borders" to join the 1¾"-wide third-border strips to the quilt top, using the mitered-corner method. Add the 3¾"-wide fourth-border strips using the butted-corner method.

11. Remove all the freezer-paper templates.

Finishing

1. Layer the appliquéd top with batting and backing; baste the layers together.

2. Quilt as desired.

3. Refer to "Cushion Finishing" on page 29 or "Wall-Hanging Finishing" on page 32 for the appropriate instructions to finish your quilted piece.

Clematis Color Keys

Cushion

Fabric color	Piece(s)
Green 1 (lightest)	2, 3, 5, 6, 8, 10, 16
Green 2	7, 9, 13, 14, 17, 19
Green 3 (darkest)	1, 4, 11, 12, 15, 18
Very pale mauve	25, 26, 28
Very pale mauve streaked	27, 29, 30
Light blue	23, 24, 31
Light periwinkle	20, 21, 22
Light purple	37, 40, 42
Medium purple	36, 38, 41
Dark purple	39, 43
Blue plaid	32
Pink plaid	34
Blue speckled	33
Magenta speckled	35
Purple speckled	44

Wall Hanging

Fabric Color	Pieces
Green 1 (lightest)	2, 7, 17
Green 2	5, 6, 8, 9, 13, 14, 16, 19
Green 3 (darkest)	1, 3, 4, 10, 11, 12, 15, 18
Salmon 1	25, 26, 28
Salmon 2	27, 29, 30
Salmon 3	23, 24, 31
Salmon 4	20, 21, 22
Salmon 5	37, 40, 42
Salmon 6	36, 38, 41
Salmon 7	39, 43
Dark green speckled	33, 35, 44
Light green speckled	32, 34

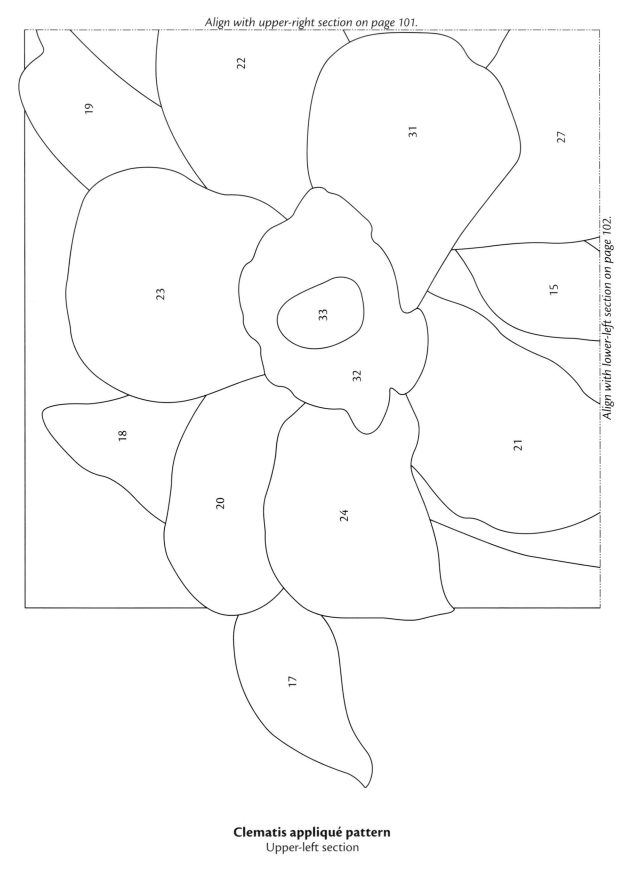

Align with upper-right section on page 101.

Align with lower-left section on page 102.

19

22

31

27

23

33

15

32

18

21

20

24

17

Clematis appliqué pattern
Upper-left section

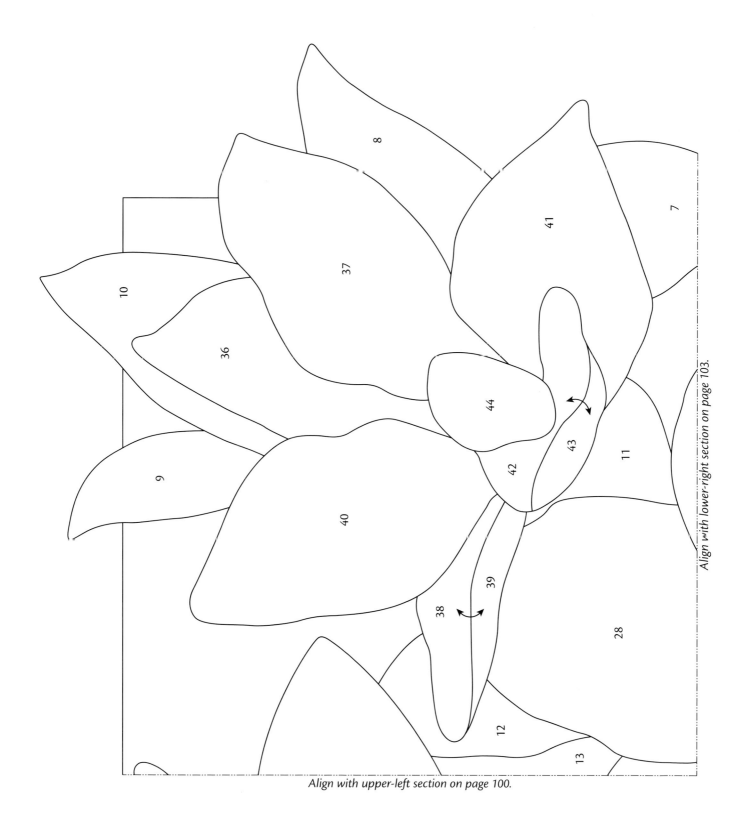

Align with lower-right section on page 103.

Align with upper-left section on page 100.

Clematis appliqué pattern
Upper-right section

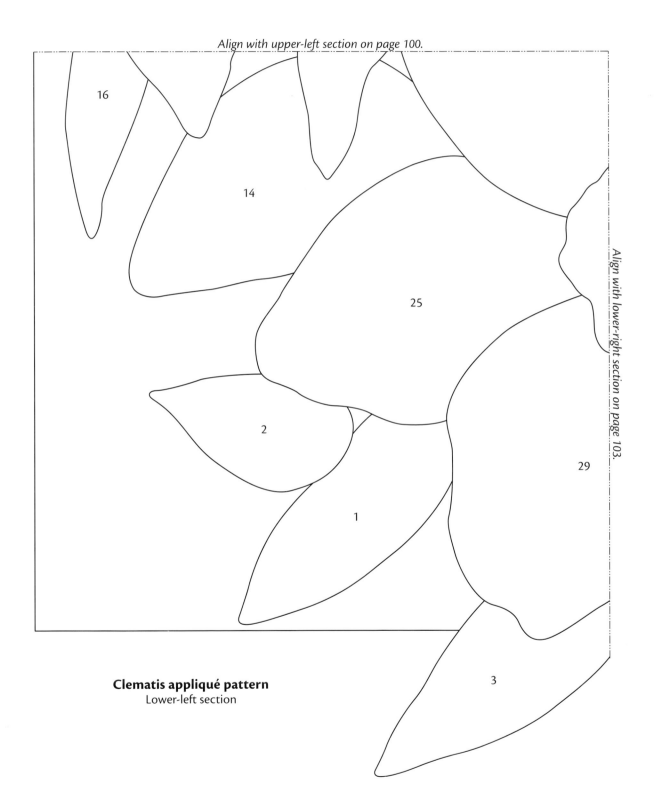

Align with upper-left section on page 100.

Align with lower-right section on page 103.

Clematis appliqué pattern
Lower-left section

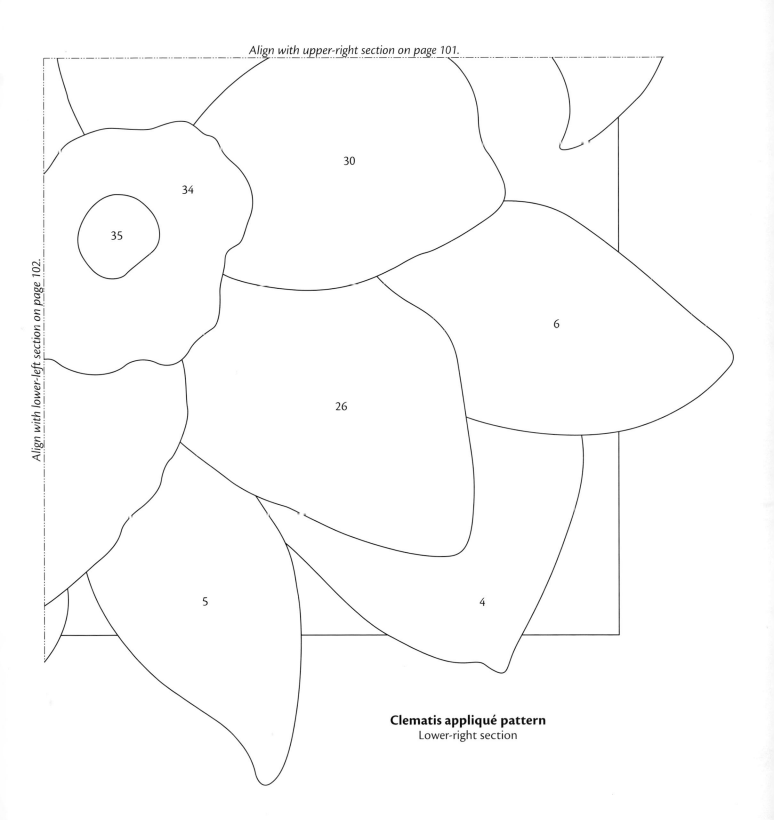

Align with upper-right section on page 101.

Align with lower-left section on page 102.

Clematis appliqué pattern
Lower-right section

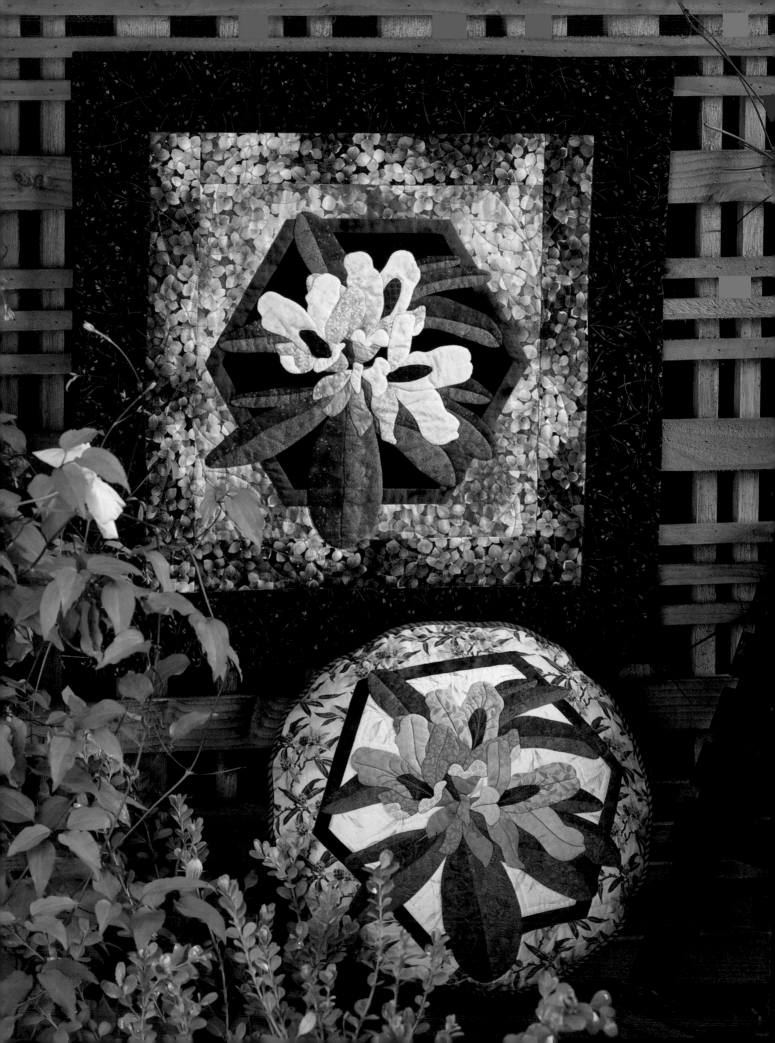

Rhododendron

Cushion finished size: 16" round

Wall-hanging finished size: 23½" x 23½"

Rhododendrons seem to be popular in landscape gardens, in part because many are evergreen and look nice year-round. But they also put on a spectacular show when the flowers bloom. They grow in a wide variety of naturally occurring colors, so you could either follow my color keys or choose your own palette. On the cushion, I used free-motion quilting to stitch in the flower stamens. The piping fabric for the cushion is a striped fabric, and when it is cut on the bias you get the effect of a twisted braid.

Materials

Yardages are based on 42"-wide fabric.

Cushion

1 fat quarter of floral for outer background

1 fat quarter of purple batik for hexagon border

1 fat quarter of light fabric for inner background

1 fat quarter of striped fabric for piping

Scraps of at least 2 different green fabrics for leaves (refer to the color key on page 107 for specifics)

Scraps of at least 8 different pink, mauve, and lilac fabrics for flowers (refer to the color key on page 107 for specifics)

Scrap of dark berry fabric for flower centers

18½" x 18½" square of fabric for backing

Fabric for cushion back: ⅝ yard for overlapped back or 1 fat quarter for zippered back

17½" x 17½" square of batting

1½ yards of cording

16" zipper to match cushion back (for zippered back only)

Plastic or vinyl for overlay

Freezer paper

Wall Hanging

⅓ yard of dark print for outer border

¼ yard of floral for inner border

1 fat quarter of pale floral for outer background

1 fat quarter of purple batik for hexagon border

1 fat quarter of dark batik for inner background

Scraps of at least 2 different green fabrics for leaves (refer to the color key on page 107 for specifics)

Scraps of at least 9 different peach fabrics for flowers (refer to the color key on page 107 for specifics)

Scraps of at least 2 different cranberry fabrics for flower centers

¼ yard of fabric for binding

25½" x 25½" square of fabric for backing

24½" x 24½" square of batting

Plastic or vinyl for overlay

Freezer paper

Cutting

All measurements include ¼"-wide seam allowances.

Cushion

From the outer-background fabric, cut:
❖ 1 square, 17" x 17"

From the inner-background fabric, cut:
❖ 1 square, 12½" x 12½"

Wall Hanging

From the outer-background fabric, cut:
❖ 1 square, 14½" x 14½"

From the inner-background fabric, cut:
❖ 1 square, 12½" x 12½"

From the inner-border fabric, cut:
❖ 2 strips, 2½" x 14"
❖ 2 strips, 2½" x 18"

From the outer-border fabric, cut:
❖ 2 strips, 3¼" x 18"
❖ 2 strips, 3¼" x 23½"

Constructing the Cushion or Wall-Hanging Top

Refer to "The Appliqué Process" on page 17.

1. Use the patterns on pages 108–111 to make a complete pattern. Trace the complete pattern onto plastic or vinyl to make the overlay.

2. Use the pattern to make freezer-paper templates for the appliqués. Refer to the color key on page 107 to make the appliqués from the fabrics indicated.

3. Center piece 1 onto the inner-background square. Appliqué the inner edges of piece 1 in place. Trim away the excess background fabric approximately ¼" from the appliqué stitches.

4. Center the hexagon shape on the outer-background square and appliqué the outer edges of the hexagon in place.

5. Appliqué the following pieces together to make units: 2 and 3; 4 and 5; 6 and 7; 8 and 9; 10 and 11; 12 and 13; 14 and 15; 16 and 17; 18 and 19; 20 and 21; 22 and 23; 35 and 36; 49 and 50.

6. Appliqué pieces 1–53 to the background, stitching in numerical order.

7. Remove all the freezer-paper templates.

Finishing the Cushion

1. Trace a 16½"-diameter circle onto paper and cut it out. Center the circle pattern over the appliqué and trace around it.

2. Layer the appliqué top with batting and backing; baste the layers together.

3. Quilt as desired, keeping the quilting inside the 16½" circle.

4. Cut out the pillow top on the drawn line.

5. Refer to "Cushion Finishing" on page 29 to finish your quilted piece.

Finishing the Wall Hanging

1. Trim the outer-background square to 14" x 14", making sure the hexagon is centered.

2. Refer to "Adding Borders" on page 23 to stitch the 2½"-wide inner-border strips to the background square, using the butted-corner method. Repeat to add the 3¼"-wide outer-border strips.

3. Quilt as desired.

4. Refer to "Wall-Hanging Finishing" on page 32 to finish your quilted piece.

Rhododendron Color Keys

Cushion

Fabric color	Piece(s)
Green 1	2, 5, 6, 9, 11, 13, 15, 17, 19, 20, 22
Green 2	3, 4, 7, 8, 10, 12, 14, 16, 18, 21, 23, 33
Green 3	24, 25, 26
Pale pink 1	36, 38, 50, 53
Pale pink 2	30, 39, 47
Pale pink 3	44
Light pink 1	32, 41
Light pink 2	40, 43, 45, 51
Light mauve pink	27, 35, 48, 49
Light mauve	28, 29, 37, 46
Lilac	34
Dark berry	31, 42, 52
Purple	1

Wall Hanging

Fabric color	Piece(s)
Green 1	2, 5, 7, 9, 11, 13, 15, 17, 19, 20, 22, 26
Green 2	3, 4, 6, 8, 10, 12, 14, 16, 18, 21, 23, 33
Green 3	24
Very pale peach 1	36, 38, 50, 53
Very pale peach 2	30, 39, 44
Pale peach 1	41, 51
Pale peach 2	43, 45, 47
Pale peach 3	32
Peachy pink 1	35, 40, 48, 49
Peachy pink 2	29, 34
Peach	28, 37, 46
Medium peach	27
Cranberry 1	42, 52
Cranberry 2	31
Purple	1

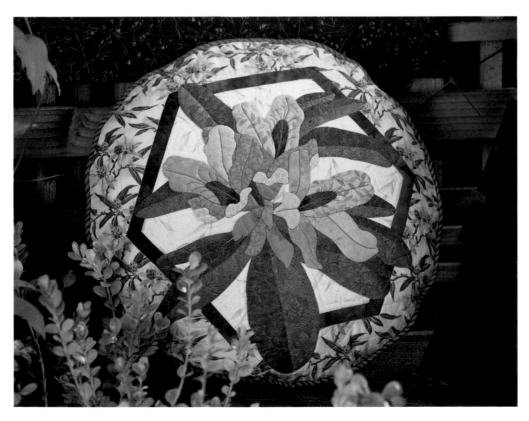

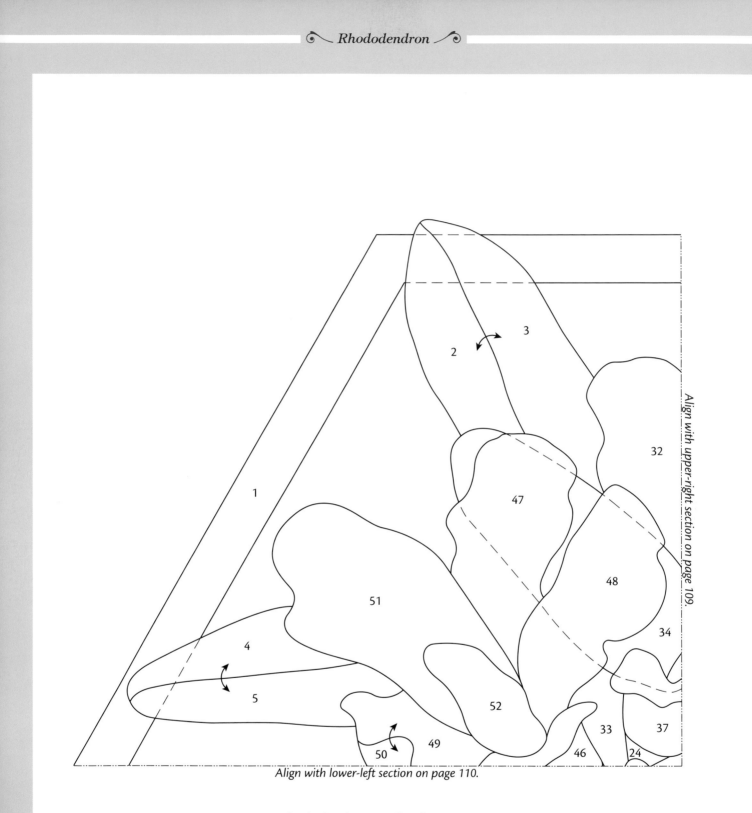

Rhododendron appliqué pattern
Upper-left section

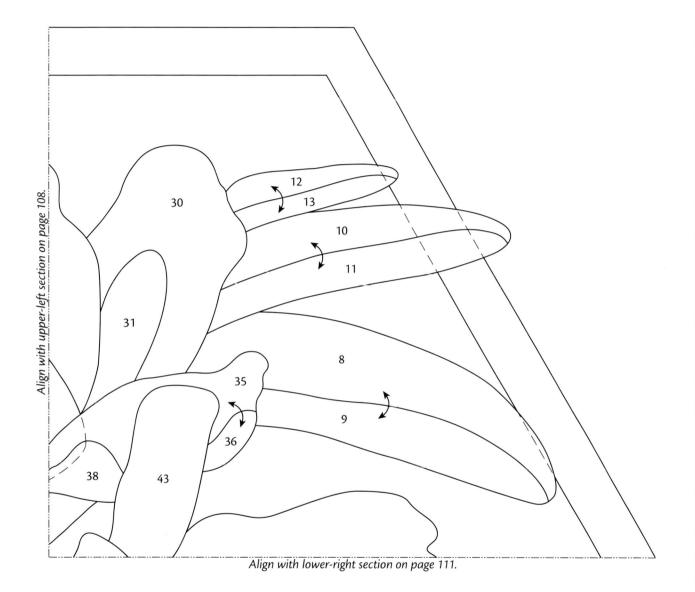

Align with upper-left section on page 108.

30

31

38

43

35

36

12

13

10

11

8

9

Align with lower-right section on page 111.

Rhododendron appliqué pattern
Upper-right section

Align with upper-left section on page 108.

53

25

26

45

29

17

6

7

27

23

28

22

Align with lower-right section on page 111.

21

20

Rhododendron appliqué pattern
Lower-left section

Align with upper-right section on page 109.

Align with lower-left section on page 110.

Rhododendron appliqué pattern
Lower-right section

Meet the Author

Susan Taylor Propst learned to quilt in 1987 when she was expecting her first child. She began her career as a quilting teacher in 1994 while living in rural Colorado. Initially she started teaching because she did not have anyone nearby to share quilting with, but soon she was able to form a small quilting group. In 1999, she and her family moved to northern England, and she quickly resumed her teaching pursuits. Since arriving in England, Susan has completed City & Guilds in Patchwork and Quilting, and in 2006 she received a Higher National Certificate in Textiles. (City & Guilds is an organization that awards vocational qualifications. Students learn techniques, design, and fabric coloration.) She enjoys teaching all levels of quilters and is popular with her students, both British and American. Although she likes all aspects of quilting, she is particularly fond of appliqué and enjoys designing patterns, including numerous patterns for her students to use in classes.

This is Susan's second book, and her second partnership with That Patchwork Place. Her first book was *Beautiful Blooms: Quilts and Cushions to Appliqué*. She currently lives in Harrogate, North Yorkshire, with her husband and two of her three children. She has found plenty of wonderful quilters in England and believes that the long dark winters are always an inspiration to quilt.

There's More Online!

To see more of Susan's designs, visit www.susantaylorpropst.com.

Learn more about Susan's *Beautiful Blooms: Quilts and Cushions to Appliqué* at www.martingale-pub.com.

Photo by Stephen Nelson.